HERE COMES MR. CASS

This is a story about trusting your forefathers while still embracing the new. It's about following your instincts, even when that means swimming against the tide, and starting from first principles in order to make something extraordinary out of nothing.

Every morning, I wake up full of ideas. There isn't space or time for all of them, but I am very lucky to have led a life where a great many of my ideas have come to fruition. This book tells the story of some of those ideas, and the people who helped me to realise them.

All through my life, I've been lucky enough to come under the influence of remarkable and generous teachers. They taught me the ropes – and sometimes showed me by example how *not* to do things! I am eternally grateful to all those people who have been an inspiration to me.

I dedicate this book not just to them, but also to my children and grandchildren, and all of those who are working to ensure the legacy of the Cass Sculpture Foundation. I hope you will find some interest or inspiration in its pages, and that you will forgive the occasional lapses of memory that inevitably accompany a long and well-lived life.

Wilfred Cass, June, 2013
CBE for Services to Art
Honorary Fellow of the Royal College of Art
Fellow of the Institute of Electrical Engineers
Honorary Doctorate from the Open University

CHAPTER 1: EARLY DAYS IN BERLIN

Locomotive Days

Wilfred, age 6

For my sixth birthday, in 1930, my father gave me a toy train. Not just any toy train: a custom-made Märklin locomotive, almost two feet long, gleaming in its hand-painted, emerald-green livery. In our high-ceilinged apartment in the fashionable Berlin suburb of Charlottenburg, my brother Eric and I looked on wide-eyed as my father sent the new engine on its inaugural journey around the elaborate model railway. Of course, Father was the real collector. But our childhood birthdays and Christmases offered a wonderful excuse to uncrate the many Märklin treasures and add new items to this miniature world.

Our huge and airy apartment was at a very fashionable address just a few blocks from the Tiergarten, and it was filled with furniture of the highest quality and precious Meissen porcelain. The apartment had perhaps fifteen rooms, and corridors so big that Eric and I could bicycle up and down with all our little friends while Father was out at work. Yet Father's train set eventually became so extensive that, during the two weeks or so that it was on display, it ran into nearly every room, and daily life required one to negotiate an obstacle course at every turn. Each year my father commissioned several unique engines or carriages in Gauge 1, the largest scale that Märklin made. Seven people from my father's factory had to work for a week to build the track, while

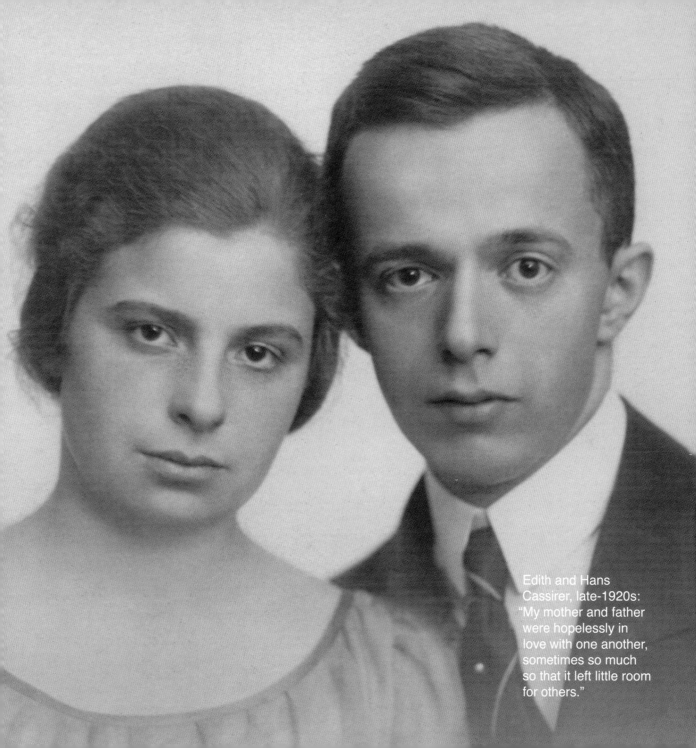

Edith and Hans Cassirer, late-1920s: "My mother and father were hopelessly in love with one another, sometimes so much so that it left little room for others."

Young Wilfred and Eric
in Germany

Father would experiment with the latest electrical technology to refine signalling protocols and make his trains run at higher and higher speeds.

As a boy, I saw only the fun of the train set. I didn't understand the reasons why my father might need the sense of escape it offered. In 1929, at just 33 years old, Hans Cassirer had been made managing director of the family business: Dr Cassirer & Co Cable Works. The firm specialised in the latest technologies for manufacturing electrical cables insulated with rubber – a lucrative business, and one that kept my father well supplied with special-order tinplate trains even while the Great Depression raged.

But despite the thriving factory and the luxurious home, life for a prominent family of Jewish industrialists in 1930s Berlin was far from carefree. Since the early 1920s, the National Socialist party had been rising in influence and power. The rumblings of anti-Semitism were growing louder by the day, and Adolf Hitler was already a name to be feared. Each fresh batch of rumours about the Nazis and their plans spread swiftly through the streets of Charlottenburg, a thriving Jewish area since the early years of that century. There you could find synagogues and *mikvah* alongside the famous cafés, theatres and cabarets of the Kurfürstendamm –

the centre of the Berlin avant-garde. The Cassirers were high-profile members of the community, although we were not very observant Jews: wealthy, cultured and ambitious, we followed no religion except that of Family.

The Cassirer Line Observant or not, we Cassirers bore a proud and famous Jewish name. In those earliest days, the nervous mix of financial depression and anti-Semitism seemed like a storm we'd be quite strong enough to ride out. And there seemed no safer stronghold at that time than the home I shared with my father, Hans, mother, Edith, and older brother, Eric.

The day I was born, 11 November, 1924, it was Anne Marie Cassirer who midwifed me into this world. Anne Marie was a medical doctor, which I'm sure was useful in the task! But more importantly she was my father's sister: from my very birth, it was apparent that this life was a family matter.

In both business and social spheres, the Cassirers felt themselves to be a breed apart. Before the Great War, the family had achieved spectacular success in commerce. My great-great-grandfather Markus Cassirer was a cloth merchant in Breslau (present-day Wroclaw, Poland). He had nine children, among them my

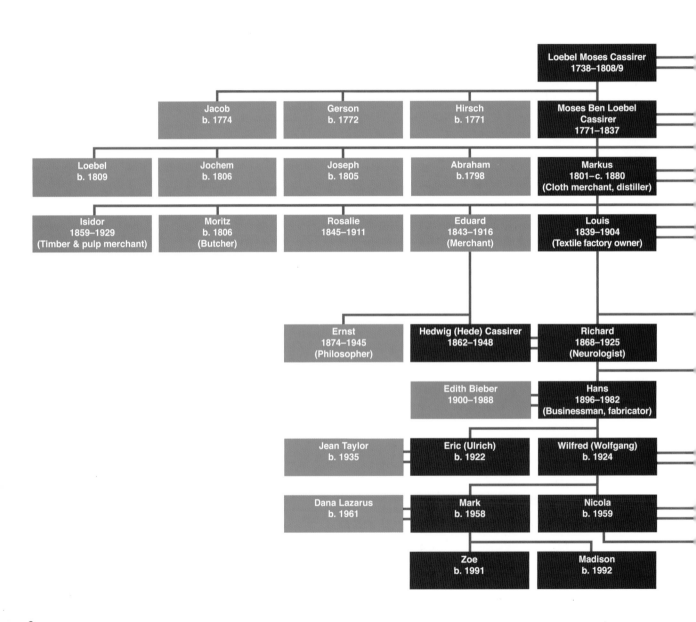

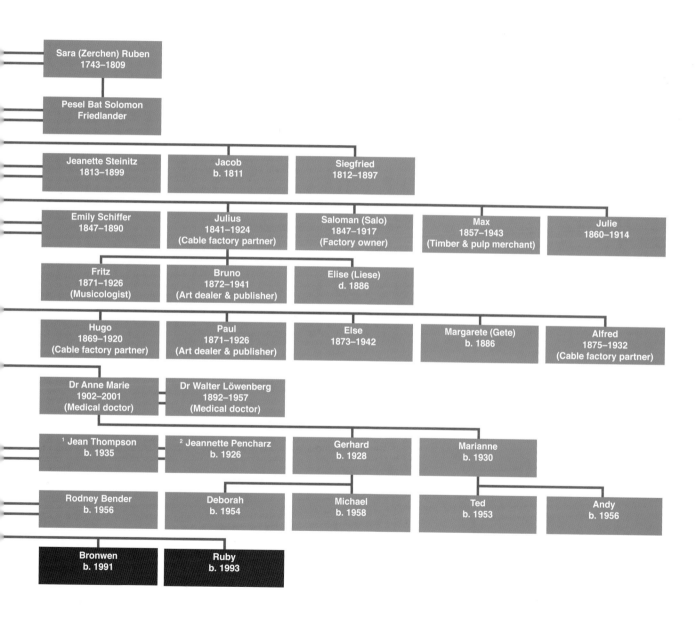

Sara (Zerchen) Ruben
1743–1809

Pesel Bat Solomon
Friedlander

Jeanette Steinitz
1813–1899

Jacob
b. 1811

Siegfried
1812–1897

Emily Schiffer
1847–1890

Julius
1841–1924
(Cable factory partner)

Saloman (Salo)
1847–1917
(Factory owner)

Max
1857–1943
(Timber & pulp merchant)

Julie
1860–1914

Fritz
1871–1926
(Musicologist)

Bruno
1872–1941
(Art dealer & publisher)

Elise (Liese)
d. 1886

Hugo
1869–1920
(Cable factory partner)

Paul
1871–1926
(Art dealer & publisher)

Else
1873–1942

Margarete (Gete)
b. 1886

Alfred
1875–1932
(Cable factory partner)

Dr Anne Marie
1902–2001
(Medical doctor)

Dr Walter Löwenberg
1892–1957
(Medical doctor)

¹ Jean Thompson
b. 1935

² Jeannette Pencharz
b. 1926

Gerhard
b. 1928

Marianne
b. 1930

Rodney Bender
b. 1956

Deborah
b. 1954

Michael
b. 1958

Ted
b. 1953

Andy
b. 1956

Bronwen
b. 1991

Ruby
b. 1993

The Cassirers and
their passions

Always enterprising,
often colourful, the
Cassirers made
their mark on German
art, culture and industry
throughout the 19th and
early 20th centuries.

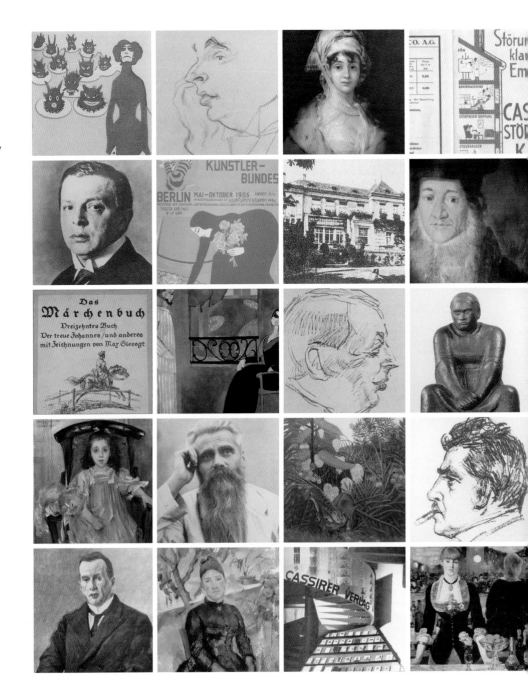

Wilfred's father and mother, Hans Cassirer and Edith [Bieber] Cassirer

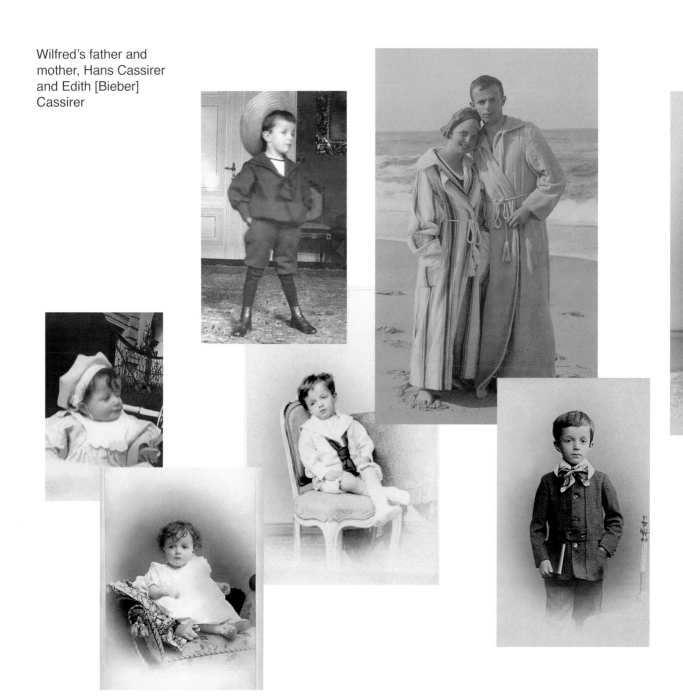

Hugo Cassirer established the cable works that brought the family to Berlin

great-grandfather Louis who inherited the cloth business and turned it into a successful textile factory. Other brothers went into the timber trade, taking advantage of a great building boom in Berlin to consolidate their fortunes.

The next generation could afford to indulge in other careers. My grandfather Richard was a brain surgeon and professor of neurology at Berlin University, specialising in the anatomy of the central nervous system. And my great uncle Paul was a very important figure in the Berlin art world, a gallery owner and tastemaker whose customers among the wealthy Jews of Berlin included a number of his relations. But the business gene runs very strongly in the Cassirer line, and grandfather's other two brothers, Hugo and Alfred, were industrialists through and through.

Hugo Cassirer was a chemist and Alfred an engineer by training. During their studies, they had learnt new techniques for cable insulation in Austria and the US. They brought this knowledge back to Germany and, with the help of a capital investment from – who else? – a Cassirer uncle, they set up the cable company that eventually passed into my father's care. At the time my father took charge in 1929, the factory had recently expanded, adding to the

Wilfred in the sandpit near the cable works, age 4

Wilfred's first business, selling sweets, age 5

original premises on Keplerstraße in Charlottenburg a splendid purpose-built facility in Spandau, where you can still visit Hugo-Cassirer-straße to this day.

I remember the old Kepler Works vividly because Nanny often used to take Eric and me to play with our toy cars in the sandpit opposite. Toy cars, Märklin trains, motor racing – these were the greatest joys of my childhood. In particular, I was very keen on motor racing, and thrilled to discover that Hans Stuck, one of the stars of the Auto Union racing team, lived in our building.

It was often my beloved Nanny who led our playtime, as my mother and father were not very 'hands-on' parents. I had the impression even then that they were hopelessly in love with each other, and that this did not leave much room for anyone else. This only increased once my father began to commute to the new factory, and we boys saw even less of him than before. Still, my early childhood was very happy, and we wanted for little. Although he always knew, down to the last mark, how much cash was in his pocket, my father had the attitude that money was for spending, not saving. There were summers by the Baltic Sea and skiing trips to Bavaria. And, of course, there were those periodic installations of the magnificent train set.

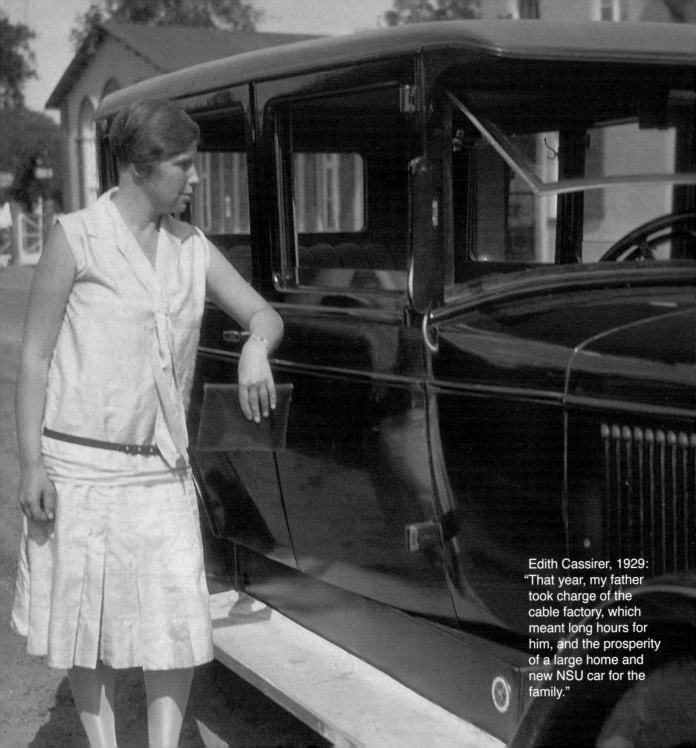

Edith Cassirer, 1929: "That year, my father took charge of the cable factory, which meant long hours for him, and the prosperity of a large home and new NSU car for the family."

The Potsdam bank that caused Edith's family's downfall

My mother once tried to send me to a summer camp for children, and the thought of it still makes me shudder. I hated everything about it: the teachers, the other children and especially the food. I was always a small and rather sickly child because of a host of food allergies – I couldn't tolerate milk or various other foods. It was one of many factors, along with my later troubles in school and the accumulating daily difficulties of life in pre-war Berlin, which amplified my mother's natural anxiety. In fact, Mother worried about me deeply for most of her life, but that may have been as much due to her own life story as to my thin frame and early educational disinterest.

My mother, born Edith Bieber, was a lively but somewhat nervous woman whose life had given her little reason to trust the world around her. The only daughter of a prosperous Potsdam banker, her comfortable middle-class life was shattered at the age of 14 when her father's bank collapsed, thanks to over-exposure to British bonds on the eve of the Great War. The family instantly fell into bankruptcy. Shamed by the failure, both of her parents made careful plans to commit suicide, going so far as to ask Edith if she wanted to join them in this final act. She refused, but they carried out their grim decision nonetheless, leaving her an orphan. Such

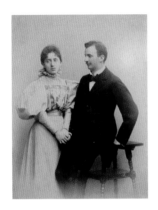

Hedwig and Richard
1860

a tragedy was not unique in Germany in 1914, at the culmination of a period of pre-war economic crisis, but of course it cast a long shadow over my mother's life.

The suicide of Herr Eugen Bieber and his wife made the headlines as far afield as New Zealand. It was not much more than five years later that Edith met and married my father, and the scandalous circumstances of her parents' death may have played a part in the Cassirer family's disapproval of the match. Whatever the reason, there is no doubt that my mother had a hard time gaining acceptance from the family: her mother-in-law barely spoke a word to her until the day she died. I think the main problem must have been that Mother was not "one of us". By choosing this orphaned girl with no connections in the Berlin Jewish intelligentsia, my father was "marrying out". In fact, you could argue that he was importing some valuable new genetic material to stabilise the Cassirer line!

Even a cursory glance at the family tree will show that the Cassirers stuck together. Wherever possible they married in rather than out – my own grandparents Hedwig and Richard were first cousins, as were Hedwig's parents, and Hedwig's brother Ernst married a cousin too. I am not sure what part those frequent intermarriages may have played, but it is a matter of record

that the stigma of suicide touched the Cassirer family deeply in those years following my parents' marriage. In 1926, my great uncle Paul, the famous art dealer, shot himself, apparently in heartbroken response to his second wife's petition for divorce. My uncle Thomas killed himself a few years later, also in the throes of an unhappy marriage. I didn't know much about these tragedies until later in life; nor did I learn how my maternal grandparents had died until I was a young man in my twenties. My mother never spoke of it. All I knew was that she hated risks, dreaded unforeseen changes, and that reading about my doings in the newspapers always frightened her.

Mother worked for a short time as an English teacher and taught me a little English at home. She had been exposed to the language through her one-time governess, an Englishwoman from Kent named Mrs Thornhill, and always held a soft spot for this nation – a connection that would prove vital before too long. But while I enjoyed some learning and reading, and grew closer to my mother through a shared love for books such as *Ali Baba and the Forty Thieves*, school did not particularly engage me. I had no interest in spelling or maths, although an early entrepreneurial spirit reared its head when I started my first "business" at the tender age of 5, selling sweets at a wedding.

The Nazis Take Over

And then, the year I turned 9, Adolf Hitler was appointed Chancellor. I knew next to nothing of politics – I didn't fully understand until years later the connection between this historic moment and the subsequent course of my own childhood. But in effect, Hitler's rise to power ended my early education, full stop.

My school had been operated by communists; everything in Germany at the time had *some* political affiliation. But somehow, upon Hitler's ascension, the school switched instantly to Nazi rule, with anti-Jewish sentiment riding high and a daily menu of bullying and harassment by the Hitler Youth on offer. Although I was a blond and pretty boy with a good German forename (I started life as Wolfgang; my brother Eric as Ulrich), my Jewish origins were no secret. Everything from my father's company to the street on which its factory stood bore my family's name: Cassirer. With little grasp of politics, but an all-too-exact understanding of the boots and blows of my classmates, I fell back on the Cassirer instinct for figuring out an innovative solution to the problem at hand: I simply stopped going.

For a couple of years I had very little education of any kind; I would head out in my school uniform, then spend the day

Ernst Cassirer,
philosopher

entertaining myself anywhere *but* in school, before coming home at the appointed hour. One of my regular destinations was the F. V. Grunfeld department store on the Kurfürstendamm, which was owned by friends of my parents. What a thrill to ride up and down in the circular glass and chrome elevator, and feast my eyes on the most marvellous range of toy cars and trains. Coming a close second was the Schloss Charlottenburg – the grand once-royal palace that housed our local museum. There I could lose myself for the whole day, looking at the marvellous decorative arts, historical exhibits and sculptures.

For my parents and their fellow Jews in Berlin, the approaching danger posed by the National Socialists was becoming impossible to ignore. Once in power, Hitler wasted no time in passing laws to exclude us from state service and curtail our participation in the medical and legal professions, and the universities. My great uncle Ernst, a leading philosopher and Kantian scholar, left his chair at the University of Hamburg and found sanctuary at Oxford University. My own family travelled to England that same year, 1933, but only temporarily. We stayed with my mother's former governess, who lived at Cranbrook in Kent. I thought it was heaven there, and I never wanted to leave.

A brochure touts the Cassirer family's Berlin cable works

Although we had onward tickets to America, after four weeks the situation in Berlin seemed to have stabilised and so, to my dismay, we returned to the flat in Charlottenburg and the once-familiar life that no longer seemed safe at all. I think my father, who was a socialist at heart, felt a great responsibility towards his workers in Berlin. The factory was still running, though Jewish businesses in Germany were operating under a very dark cloud as the Nazis continued their inexorable rise. In 1935 my father was forced to sell the cable works to Siemens, a good Aryan company, for less than 5% of its real value. Almost as soon as the sale was completed, he visited England again to make arrangements for our relocation – but this time, permanently.

CHAPTER 2: A NEW LIFE IN ENGLAND

New Heights

So it was that at the age of 11, speaking only a few words of English, I was consigned to the care of an English boarding school. But before you spare me too much pity, I should tell you a little about Frensham Heights, the college in Surrey to which my brother Eric and I travelled by train that January in 1936.

Frensham Heights:
A progressive education

I am sure the phrase "1930s English boarding school" conjures up pictures of deprivation and misery: stern masters, meagre rations and rigid discipline. Forget them all! Apart from the mandatory cold showers, Frensham Heights was nothing like the stereotypes. For a start, it was coeducational: my mother was deeply suspicious of single-sex schools, which she considered hotbeds of homosexuality. And it was progressive in many other ways, too. Founded in 1925, the school took as its guiding principle 'faith in human nature and the spiritual powers latent in every child'. Frensham Heights threw out the narrow curriculum of reading, writing, arithmetic and rugby; in its place, the first prospectus announced 'an unusually wide choice of leisure occupations under qualified teachers; these include dramatic work, photography, practical work in the workshops, including carpentry, metalwork, weaving, leather work, jewellery, collections, gardening and team games'. By the time I joined the school, art and pottery were particular strengths.

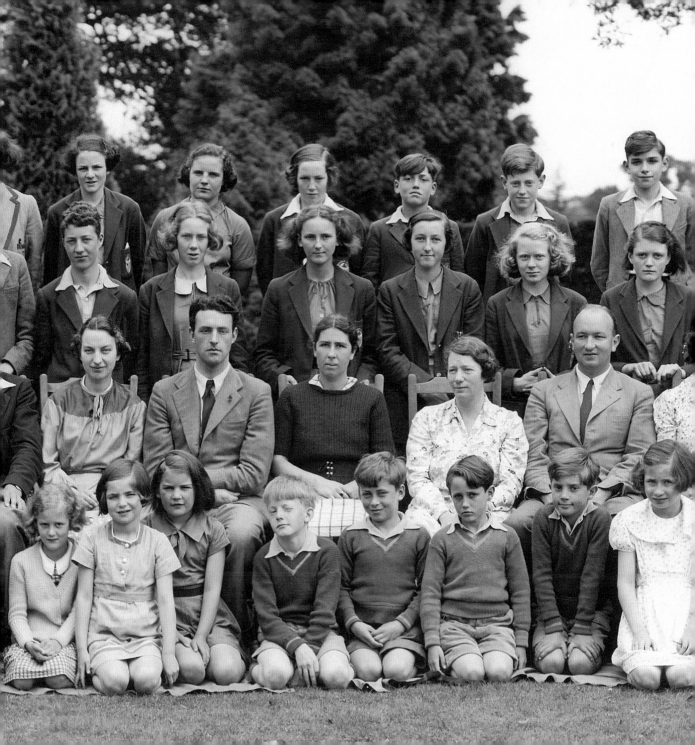

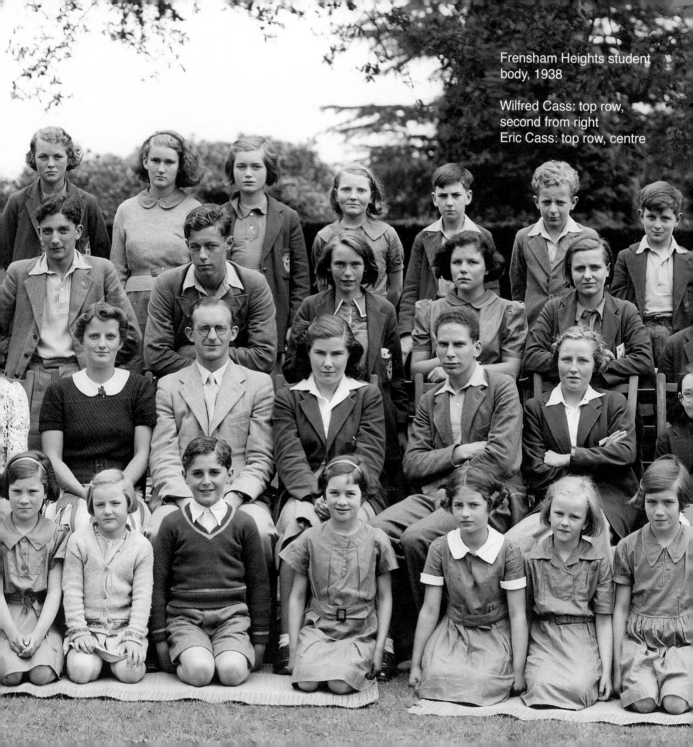

Frensham Heights student body, 1938

Wilfred Cass: top row, second from right
Eric Cass: top row, centre

Frensham Heights, 1938:
"The phrase '1930s English boarding school' conjures up pictures of deprivation and misery: stern masters, meagre rations and rigid discipline. Forget them all!"

Summer 1936

Frensham Heights Magazine

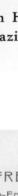

FRENSHAM HEIGHTS.

...LIC CO-EDUCATIONAL SCHOOL FOR BOYS AND GIRLS.

Chairman of the Governing Body :
Mrs. DOUGLAS-HAMILTON.

Principals :
Mrs. R. W. ENSOR. Miss I. B. KING.
Assisted by a staff of experienced and qualified men and women teachers.

Medical Officer :
C. VERE NICOLL, Esq., M.R.C.S., L.R.C.P. (Lond.)

Bankers :
National and Provincial Bank, Ltd.

Telephone : FRENSHAM 184. *Telegrams :* Heights, Farnham.

Station : Farnham, Southern Railway, 1¼ hours from Waterloo. School is 3 miles from Station.
'Bus runs every hour. School car can meet trains by appointment ; charge, 4s. single journey.

Motor route from London : 42 miles ; Putney Bridge, Esher, Guildford, Farnham.
Hotels : Bush Hotel, Farnham ; Frensham Pond Hotel, Frensham.

18

Frensham Heights
headmaster
Paul Roberts

It's certainly possible that my parents consulted my father's relatives on the choice of a school for their boys. Father's great uncle Max Cassirer had funded the first progressive boarding school in Germany in 1910 – the famous Odenwaldschule in Ober-Hambach, which was the brainchild of Max's daughter Edith (not to be confused with my mother) and her husband Paul Geheeb. Like the founders of Frensham Heights, their humanist educational principles saw the work of the head and the hand as equally valuable, fostered the development of lifelong social skills, and treated children as individuals.

In my time, Frensham Heights was under the leadership of a visionary headmaster named Paul Roberts. His philosophy was incredibly influential on my development. He led us by example, fostering humility and mutual respect amongst both pupils and teachers, all of whom called each other by their first names. Paul Roberts believed strongly that everybody is good at something, and the school's job is to find it. Independent, critical thinking was valued far more than rote learning, and it was here that my earliest forays into entrepreneurship were celebrated and encouraged.

To begin with, my chief delight was that people at school were nice to me. This had not been the case at all in Berlin, where name-calling and blatant discrimination had been the norm from

fellow students and teachers alike. At Frensham, a number of scholarships had been made available for refugee children and the atmosphere was incredibly welcoming. For the first time in my short life, I began to enjoy school. Frensham's liberal attitude meant that thinking for oneself was encouraged, but learning the usual academic stuff was not always seen as 'necessary'! I soon became quite fluent in English, and within a matter of months I had almost completely lost my German accent. My brother, being a little older, found the transition and adjustment more of a challenge than I, but he settled in quickly too.

For our parents, the stresses of moving to England must have been immeasurably greater. Not only did they lack the child's optimistic adaptability and capacity to learn, they would also have been constantly anxious about the dire political and social state of the Germany we had left, and the challenges that might face those family members who had stayed behind. Although my mother's English was good, my father was not well versed in the language of his newly adopted homeland. A couple of weeks after arriving, my mother wrote to her friend Hilde, "Now Hans is beginning to recover slowly, to become less nervous, and to take the first steps to 'settle'. In this direction he first of all takes English lessons; reads many English newspapers; besides we are looking for a furnished flat for the first period, comprising about two rooms,

bathroom and kitchen, so that the hotel restlessness will be done with as soon as possible, so that he may also meet people and make telephone calls undisturbed, and last but not least we do not have to be all the time among strangers."

By March that year, my parents had found a small, furnished apartment at 89 Langford Court, Abbey Road in London NW8. Although they had still not ruled out the possibility of moving to America, Hans was looking for work and plugging away at his English lessons. The real bright spot was that Eric and I were doing well at school, or at least enjoying ourselves. Mother writes, "The children are very happy in their college. They really have a great time there. The only question is whether it is not too great a time. We visited them three weeks ago on the occasion of a concert by a Jewish cellist from Frankfurt, and returned enthusiastic in every respect. Their study of English seems to proceed well too."

Fun and Games

Perhaps, with hindsight, I was having too much fun at Frensham Heights! I certainly remember spending a great deal of time tinkering around in the woodworking shed, and doing pottery in the art department. I also became captain of the junior cricket and hockey teams. Although I was learning a lot in those years, Frensham's genius was to develop character and self-reliance

Cricket at Frensham Heights, circa 1938

without too much heavy-handed guidance. If you didn't want to go to a class because you found it uninteresting, you could do other things. The phrase 'think outside the box' is much more recent in origin, but it really describes what Paul Roberts was encouraging in us at Frensham in the late '30s.

Of course, I did do some book learning! I read a great deal – all of Dickens' books, philosophy books and really anything I could get hold of. My relationship with my mother Edith was always close and quite intellectual; dearly as she loved him, she couldn't discuss philosophy with Father, who was not one for talking about anything much apart from business. So I was her main conversational sparring partner. Back home from school, I spent a lot of time with her discussing Freud – who, like us, fled Nazism to spend his final years living in London – and other aspects of psychology.

The social skills I learned at school – and later, in the army – have ultimately proved a lot more useful to me than the pottery or woodworking. Although I was, to begin with, a rather intense and serious boy, I soon grew to love the fun of a co-educational school, getting to know how girls ticked, actually liking them and treating them as equals. The nude swimming was quite a draw, too, as it happens!

Frensham Heights, 1938: "At Frensham Heights, thinking for oneself was encouraged, but learning the usual academic stuff was not always seen as 'necessary'!"

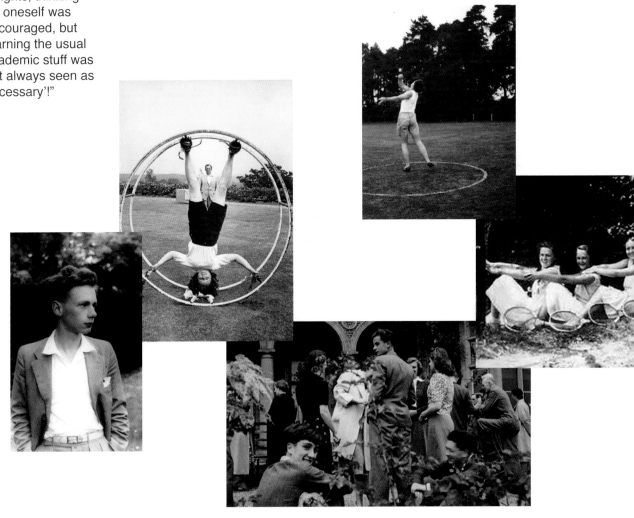

Swimmers at
Frensham Heights

A girl called Faith Brook, who was a fellow pupil for a short while, came to Frensham from America and brought with her the first Monopoly set I ever saw. This occupied my time pretty exclusively for long periods, and I designed a number of enhancements that helped make the games last much longer – including chequebooks with unlimited cash funds. Faith later became a famous actress, starring in *To Sir, With Love* with Sidney Poitier, among more than 90 film and TV roles.

I was determined to follow in my father's footsteps and make a success of myself in business, although my father and I were not much alike – to my mind my brother Eric took after him far more closely in character and disposition. In January of 1940, soon after I turned fifteen, my mother wrote to her friend Hilde in Israel, "Wolfgang still has eighteen months to his exams and will probably not have as many difficulties [as Ulrich]; although in character he is not reserved, you never can tell what he really thinks; but he is very witty and his whole conduct resembles more that of Hans. His highest goal is to become a 'business man' and Hans believes he has a natural gift for it. For six months now he has a 'Bicycle repair establishment' in his school together with another boy, and for Christmas brought home 23/- profits. (Chairman of this company is a teacher!). Besides he plays the violin with enthusiasm; the results are not visible but he is happy doing it."

MACIRRER LTD;
At Workshop

CYCLE REPAIRERS,
PUNCTURE SPECIALISTS,
MODERATE PRICES.

**XMAS GREETINGS
FROM
MACIRRER LTD.**

Business cards from a teenaged Wilfred's bicycle repair venture, Macirrer Ltd.

This bicycle repair company, which I named Macirrer Limited, was indeed my first business, and I was very proud and conscientious: I designed promotional material and kept proper accounts. It came about because I noticed that when students left the school they usually left their bicycles behind, as they were generally in a poor state. I liked working with mechanical things, so I got a space near the workshops to take these scrap-heap cycles apart and rebuild them as unique new bikes. I had a partner called Johnnie Mackay (Mac), who was a few years older than I and a brilliant engineer. Meanwhile I looked after the finances, including a company chequebook. The first year's profits were 23 shillings, which I thought was very satisfactory for a boy of barely 15.

My best customer at the time was a girl called Jean Rowe. According to the meticulous books I kept, she seemed to have a puncture on her bike every day, requiring my attention at a cost of one penny. Sure enough, she became my girlfriend, although it appears I continued to charge her for bicycle repairs!

Mac was a few years older than me, and when he left school I took on a new partner: Richard Hadfield, who much later became my consultancy partner. Richard and I were very close – for a long time we thought I ought to marry his sister Maribel, but she and I simply weren't a match, however neat a solution it seemed to

Inside of the business card, a promotional book and cheque from Wilfred's bicycle repair venture

LET THIS B

" If your bike is broken and your'e feeling blue.

take it to MACIRRER like the wise folks do.

If your bike makes not,and you make not too,

take it to MACIRRER like the wise folks do.

It your wheels are buckled and wont run true,

take it to MACIRRER like the wise folks do.

FRENSHAM HEIGHTS BANK.

....................19....

....................19......

PAY...

L160|5|37

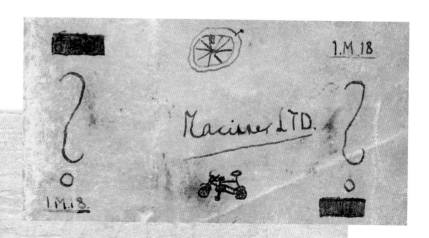

YOUR · SLOGAN

If your bike wont pass the test they say to you,

take it to MACIRRER like the wise folks do,

Let this be the slogan that you will not rue,

trade always with MACIRRER like the wise folks do

With the compliments of MACIRRER Ltd.

K. Mackay.

W. Cassirer

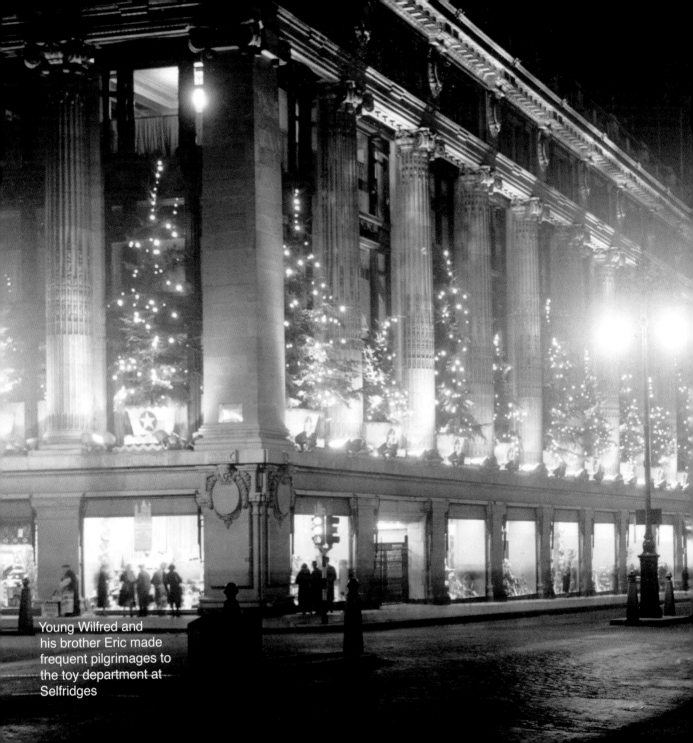

Young Wilfred and his brother Eric made frequent pilgrimages to the toy department at Selfridges

Richard and me. He was a very bright boy back at Frensham, and later took a first in economics at Reading University.

Testing Times

Most boys look forward longingly to the school holidays, but I found them extremely tedious. Money had been tight since the Nazis seized the Berlin factory, and there were no more skiing holidays or summers by the sea. What was worse, my parents continued to speak German at home – in fact they did so until the end of their lives – and I hated it. At school, I grew more and more to think of myself as an English boy; at home, I felt like the outsider. But at least those boring stretches of time in London were enlivened by visits to Selfridges with Eric – at least two or three times a week at one point. We would read magazines, and closely examine the latest Dinky toys to add to our collection. (At that point it must have numbered over a thousand cars, along with a multi-storey garage with its own elevator: what lucky boys we were!) I loved the shop so much that I got to know every department and a lot of the staff. It began an interest in retail that has lasted all my life, and spilled over to my son, Mark.

My father was preoccupied in those years with getting the rest of his family out of Germany, even returning at great personal risk in 1938 (the year that culminated in *Kristallnacht* and the real

Paul Cassirer

beginning of the Holocaust) to bring his uncle Bruno and other Cassirers to England. Even though they had long been high-profile targets for the Nazi regime – Hitler had attacked my great uncle Paul Cassirer by name in a speech as far back as 1920 – my father's relatives thought they would be spared thanks to their secret defensive weapon: art.

Paul Cassirer and his cousin Bruno had been pivotal figures in the early 20th century art world. Their gallery was largely responsible for bringing French Impressionism to Germany – Degas, Monet and Cézanne were just a few of the artists whose work they introduced to Berlin, along with Munch and van Gogh. After a lifetime of their collecting and selling to relatives, the Cassirer family had amassed important collections of impressionist artworks.

Up until 1938, the Cassirers thought they could appease the Nazi powers by handing over Monets and Cézannes to Goering and his cronies. But as the outbreak of war grew closer the game changed, and my father could see that no amount of art would be sufficient to guarantee their protection. Thanks to the foresight and efforts of my father and others, Bruno and his family escaped safely to Oxford. And in fact almost all the remaining Cassirers

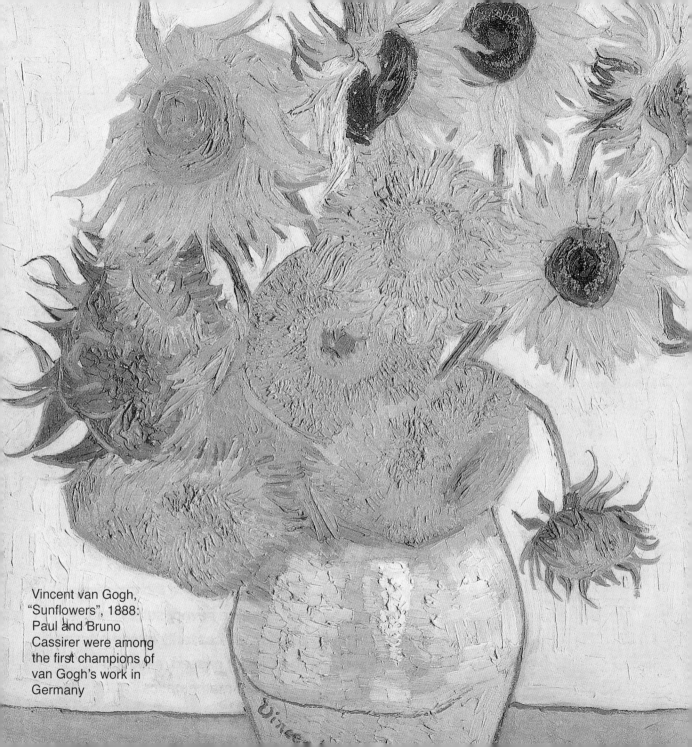

Vincent van Gogh,
"Sunflowers", 1888:
Paul and Bruno
Cassirer were among
the first champions of
van Gogh's work in
Germany

Paul Cézanne,
"Madame Cézanne
in the Conservatory",
1891

managed to leave Germany and Austria in time. Tragically, my father's cousin Toni was not so lucky. She died at Theresienstadt concentration camp along with her husband, Dr David Koenigsberger.

Although England had embraced us as refugees in 1936, once the war began in earnest all German-born residents came under scrutiny – regardless of whether they were Jewish or not. In 1940, my father and my older brother were both temporarily interned as enemy aliens, along with thousands of other German and Austrian immigrants. It was a desperately worrying time for us all, but I was insulated to some extent by the self-centred nature of the teenage brain, and by the fact that back at Frensham Heights, my exams were looming! The Headmaster wrote to my parents that I would never pass any exams as I was not interested and rather lazy – which I was most affronted by, especially considering I had given his wife such a good deal on a reconditioned Macirrer Ltd. bicycle. Spurred on by Mr Roberts' words, and with the School Certificate just five months away, I decided that the time had come to study every subject at the greatest speed – even if I still didn't necessarily attend classes. My late burst of effort was rewarded: I passed, although not brilliantly, in every subject other than mathematics.

In 1941 I left Frensham, reluctantly, at the age of 16. With Father and Eric's future prospects uncertain, there was little income at home, so I had to start working in earnest. I entrusted the Macirrer business to my friend Richard Hadfield, who was staying on at school to take his A levels – something that made me extremely envious at the time. But I had my own path to follow; although Frensham seemed like the whole world to me then, in fact my adventures were only just beginning.

CHAPTER 3: OFF TO WORK

Humble Apprentice

At the start of the war, I was too young to fight, and also – thankfully – too young for my German background to put me under the threat of internment as an 'enemy alien'. Instead, I began learning the trades that would fire my interests from that time onwards – trades that, as it turned out, would play a big part in the conflict in Europe. The Second World War was a different kind of war than had come before – one fought in the laboratory as much as on the battlefield. The race to develop new technology for communications, transportation and, of course, weapons affected all of us in different ways. For me, it was the gateway to a lifelong interest in the world-altering possibilities of electronic technology.

Able-bodied men were in short supply at that time: almost anyone older than 18 was fighting in Europe and North Africa, leaving the lads my age to keep things moving along on the home front. So when I showed up on the doorstep of Arthur Marriott Limited in Loughborough, Leicestershire, looking for an apprenticeship in their electrical repair business, they didn't have much choice. There was only one engineer and repairman left in their business, which did electrical work for everyone in Loughborough, from family homes to the large Brush Electrical Works factory.

His name was Fred Sargent, and he was a genius. He could do everything from fix a radio to rewire the factory – and he was smart enough to see that I didn't know anything! But his entire staff had been called up, and he grudgingly agreed to take me on for a pound a week. Minus my 50p per week in lodgings, I wasn't exactly riding high. My first digs away from the familiar surroundings of home and school were with a lovely family in town, who were incredibly kind to me and made me feel welcome. But their house was tiny, and my cramped quarters were a very long way from the convivial swimming parties of Frensham Heights; further still from the high corridors of the grand apartment in Charlottenburg. But those were days when all of us were grateful simply to be alive. Although I longed to join up and have a pop at the hated Nazis, I felt very lucky to have a job – and an interesting one, at that.

Luckily, my boss Fred Sargent was a patient man, and a good teacher. I wound up learning more in my year with him than possibly any other such short time in my life. It was like learning English at Frensham Heights: total immersion in a brand new world. I discovered that pulling up the floorboards to get to the wiring was easy, but putting them back, not quite so easy; that an AC set plugged into a DC outlet was a great way to blow up

Recommendations from Marriott and Leicester College, 1942 and 1945: "My early jobs and education inspired an interest in electronic technology that sticks with me to this day."

ARTHUR MARRIOTT LIMITED

ELECTRICAL AND RADIO ENGINEERS

9 HIGH STREET, LOUGHBOROUGH

Ref's. AHM/MM

Tel. 2564

October 3rd 1942.

This is to certify that Wilfred Cass has been in our employment for one year.

During this period he has proved to be of good character reliable and willing.

He has had good experience during the short period he was with us, he is used to screwed tube, close joint, T.R.S. and cleat wiring, also some switchgear experience, and he was getting very efficient on Radio repairs.

We recommend him to anyone requiring his services, and will gladly give a detailed account of the Electrical work he has been engaged on to any concern interested.

He leaves us on his own accord with the view of living with his parents somewhere in London.

Yours faithfully
For Arthur Marriott Limited.

A.H.Marriott

re:- Application for University Entrance.

17/10/45.

I have much pleasure in supporting the application of L/Sgt. CASS, who has been with me at the Leicester College of Technology- as a Military Assistant Instructor. to the men sent from R.E.M.E., for courses in D.C A.C. and Radio.

He came to the College on February 5th 1945, and we were so pleased with his work that I asked that he be retained on the staff for a further period.

I should like to see him pursue his studies further and obtain the B.Sc. Special Degree in Physics - Radio.

(signed) L.W.Kershaw, O.B.E.
Principal,
Leicester College of Technology.

Palm reader's diagnosis, 1947: "I had my palm read on a holiday trip to Blackpool, and looking back, I think they've done a fairly accurate job. It makes me wonder if I should have given the violin a better go – maybe I still will!"

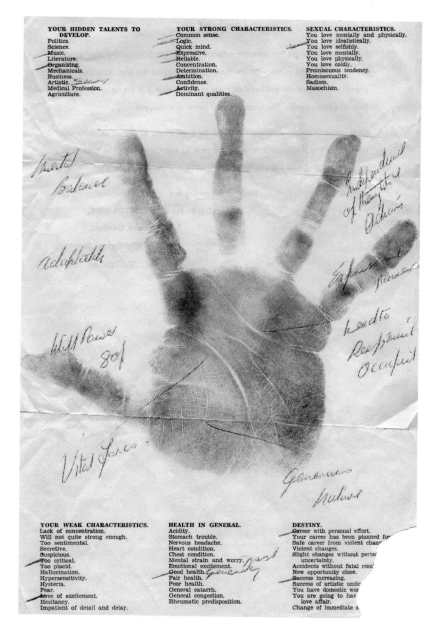

YOUR HIDDEN TALENTS TO DEVELOP.
Politics.
Science.
Music.
Literature.
Organising.
Mechanicals.
Business.
Artistic.
Medical Profession.
Agriculture.

YOUR STRONG CHARACTERISTICS.
Common sense.
Logic.
Quick mind.
Expressive.
Reliable.
Concentration.
Determination.
Ambition.
Confidence.
Activity.
Dominant qualities.

SEXUAL CHARACTERISTICS.
You love mentally and physically.
You love idealistically.
You love selfishly.
You love mentally.
You love physically.
You love coldly.
Promiscuous tendency.
Homosexuality.
Sadism.
Masochism.

YOUR WEAK CHARACTERISTICS.
Lack of concentration.
Will not quite strong enough.
Too sentimental.
Secretive.
Suspicious.
Too critical.
Too placid.
Hallucination.
Hypersensitivity.
Hysteria.
Fear.
Love of excitement.
Hesitancy.
Impatient of detail and delay.

HEALTH IN GENERAL.
Acidity.
Stomach trouble.
Nervous headache.
Heart condition.
Chest condition.
Mental strain and worry.
Emotional excitement.
Good health.
Fair health.
Poor health.
General catarrh.
General congestion.
Rheumatic predisposition.

DESTINY.
Career with personal effort.
Your career has been planned for
Safe career from violent chan
Violent changes.
Slight changes without perio
 uncertainty.
Accidents without fatal resu
New opportunity close.
Success increasing.
Success of artistic unde
You have domestic wor
You are going to hav
 love affair.
Change of immediate s

a radio; that the men in the factory don't feel too confident when you walk in to fix a motor and ask, "Which one is it?"

Eventually, however, I got the hang of it, and began working on bigger jobs. One of these included mending motor circuits in the Brush electrical works in Loughborough – a factory that is still in operation. I dimly remembered the excitement of visiting Father's factory in Berlin as a child, and now I was back in the same kind of world, but with a vital contribution of my own to make. That work inspired a real interest in the latest electronic technology that sticks with me to this day.

Despite the liberal ethos of Frensham Heights, I was still a fairly sheltered young man by the time I left school. Starting work at Arthur Marriott opened my eyes to the ways of the world in all sorts of new directions. For example, next door to the house where I boarded was a much larger house occupied by Steve, the boss of the Brush works. My host family had a glamorous 20-year-old daughter named Maisie who had, the year before our arrival, been seduced by this esteemed neighbour, resulting in an unacknowledged baby daughter. I remember, every morning, Maisie would push the pram out into the road so that she and her child could "wave goodbye to Daddy" as he drove to work.

Answering Service

Eventually, Sargent was called up to army service. I had learned a lot, but not enough to be an apprentice without a master. So I moved back to Putney, where my parents were living by then, and began working at Modern Telephones in Tottenham Court Road.

I joined Modern Telephones chiefly because it was run by a friend of my father's, a Mr Ivens. But I also wanted to learn more about manufacturing, and that company was one of the most innovative makers of telephones in the country. They also doubled my salary, to a remarkable two pounds per week! For that princely sum I was working in the factory wiring phones and doing other electronics jobs, all the while keeping my eye on the post, waiting for the call to service that I not only knew would come, but that I was determined to answer.

Meanwhile, my journey from callow youth to Man of the World continued. During wartime, Britain's factory floors came under female rule. The only men to be found at Modern Telephones in 1942 were teenagers like me, and those too old or sick to be called up. At Christmas time, the women in the factory would get blind drunk, and if they caught a male of any age they would relieve him of his trousers. It was terrifying! I learnt my lesson the hard way: if you want to keep your pants on, keep your wits about you, at least when a hundred women and a lot of stout are involved.

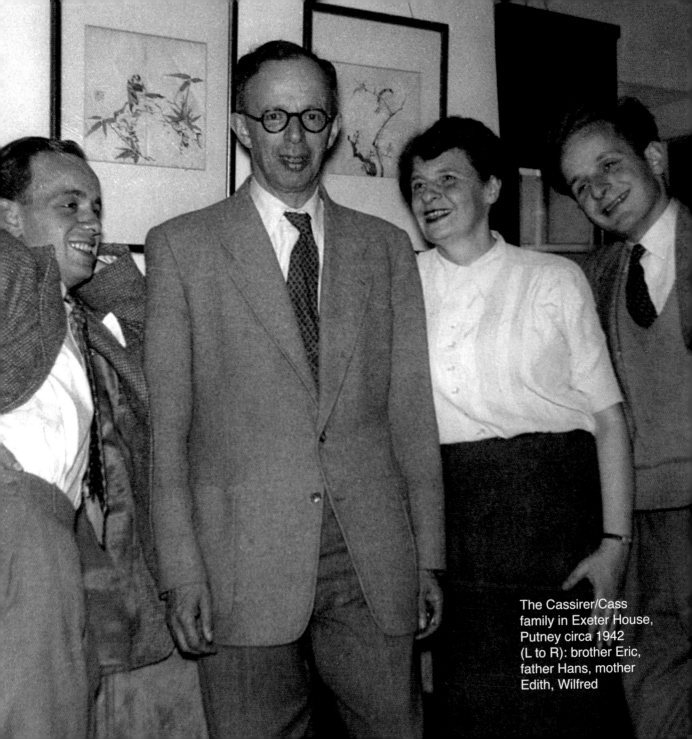

The Cassirer/Cass family in Exeter House, Putney circa 1942 (L to R): brother Eric, father Hans, mother Edith, Wilfred

By the following summer I had found my feet with the ladies –
to some extent, at least. I remember with particular vividness a
company outing to Margate. That town at the time promised an
exciting day by the seaside, and was very popular with London
factory workers. As soon as I arrived, excited and carefree, and
possibly showing off just the tiniest bit to my then-girlfriend, I
jumped headfirst into a swimming pool. Unfortunately, the pool
was nearly empty. My tongue was badly lacerated in the incident,
but I wasn't going to let that slow me down, and I spent the day
snogging the lucky girl anyway. By the time we returned to London,
I was unable to speak and rushed to hospital for some quick
repair work!

That year, however – 1943 – the postman did, indeed, arrive with
a letter from His Majesty. Modern Telephones would have to find
some other poor sap to lose his trousers that Christmas: I was
heading into the army.

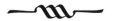

"By 1944 it was obvious that the war would be won by technology, not by brute force. Anti-aircraft guns like these were some of the first to be sighted by computer."

CHAPTER 4: <small>WARTIME</small>

England Expects

It was just before my 19th birthday that I got the call I'd been waiting for. I was to report to the Maryhill Barracks in Glasgow, Scotland, for basic training in the British Army. I wasn't the first of the London Cassirers to join the war effort – my father and brother had both already been called up, despite the strange experiences that befell German immigrants in Britain during the war's early days.

When war broke out, almost all Germans and Austrians living in Britain were sent to internment camps. Father's story mirrored that of many German Jewish refugees. He was sent, briefly, to camps in Lingfield, Surrey, and then to the Isle of Man. By that time the British government came to its senses and realised that Jews who had *fled* the Nazis probably were more useful in the Army than being interned as potential Nazi spies. Many of the former internees were pressed into service in the Pioneer Corps, including my father. The Pioneer Corps was responsible for logistics support to the fighting forces of the British Army, and on the whole their tasks were rather low-status: latrine digging, stretcher bearing, road laying and so on. Nevertheless, thousands of German Jews proudly served the Allied Forces in this way; many went on to die in combat, while others played a crucial role in the Normandy landings. My father, however, was in his mid-

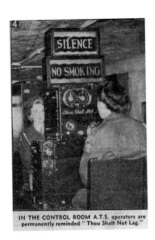

IN THE CONTROL ROOM A.T.S. operators are permanently reminded " Thou Shalt Not Lag."

A war of technology: tracking enemy aircraft

forties and was not a physically strong man; he was never sent overseas and was invalided out of the army in 1942 after a year or so of service.

I say most immigrants were sent to internment camps: some young men didn't fare so well, including my brother Eric. After the fall of France and declaration of war with Italy, fear of invasion tightened its grip on Britain, and the government redoubled its efforts to eliminate the threat of immigrant spies. Thousands of Germans, including many, many Jews and other anti-Nazi refugees, were sent to Canada and Australia. In 1940 Eric went straight from school to the infamous HMT *Dunera*, for transport to Australia, and survived a harrowing two months at sea facing dangerous overcrowding, inhuman conditions and horrific treatment by the guards. When the ship arrived in Sydney and the Australians discovered what conditions were like on board there was a public scandal, culminating in a court martial for the officers responsible and questions in the House of Commons. By petitioning the Governor General, we managed to get Eric back from Australia somewhat sooner than most of the 'Dunera Boys'. On his return to England, he, too, joined the Army, despite the less-than-kind treatment he had received at the hands of the

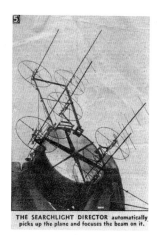

THE SEARCHLIGHT DIRECTOR automatically picks up the plane and focuses the beam on it.

Radar guided searchlights

crew and officials on board the *Dunera*. He was eventually sent into Germany, where he helped set up the British Forces Network radio service in Hamburg.

Being too young to be seriously considered an enemy agent when war broke out, I had enjoyed the safety of Frensham Heights and Loughborough. By the time I turned 18, in November 1942, I was just getting into the swing of my new working life in London. I had a lot going for me at Modern Telephones, plus I was small and thin, generally not the Army type. And yet I was determined to answer if called. After all, I knew what the Nazis were all about. I knew that the possibility of an invasion was very real – and that it could succeed. I'd already had that experience at first hand, when my entire life in Berlin had been invaded and shut down by the Nazis. Even if I'd only been a small child then, I felt I knew what those people were capable of – knew it far more viscerally than any of my English friends. And, of course, everyone I knew was being called up, too. Richard Hadfield and I had both thought we'd be pilots, but I'd amassed too many illnesses and not enough A levels to go into that line. So while Richard went to Rhodesia to train as a fighter pilot, in November of 1943 I boarded a train for Glasgow, and one of the toughest times of my life.

Top: Wilfred's Record
of Service
Bottom: Mobile radar
tracking unit

RECORD OF SERVICE

d Office Stamp

ARMY F

M.F. RECORDS

No. 14472324 Rank Cpn

Name CASS. W.R
(in block letters)

Served in Regts/Corps as follows :

	Regt./Corps	From	To	Assn. joined with date	Remarks by As
a	GSC	25/11/43	17/5/44		
b	REME	18/5/44	27/3/46		
c					
d					

12/4/46

Record Officer R

s card should be presented or sent by the person named above to the Regt/Corps A
shes to join or from which he requires assistance.
Secretary of the Association should stamp and date the card in the relative column wh
ins the Association.
ou send this card by post, do not fail to enclose your address.

Wt. 40594/221 500M 1/46 K JL/

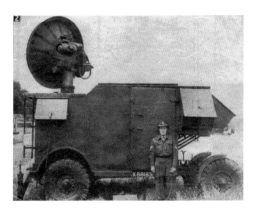

Top: Wilfred's release from the army
Bottom: An anti-aircraft gun

"My experience with telecommunications was deemed important to the national rebuilding effort, meaning that I was released from the army quickly to get to work on the country's infrastructure."

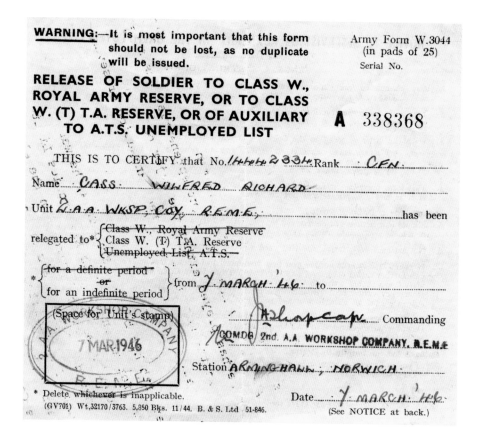

WARNING:—It is most important that this form should not be lost, as no duplicate will be issued.

Army Form W.3044
(in pads of 25)
Serial No.

RELEASE OF SOLDIER TO CLASS W., ROYAL ARMY RESERVE, OR TO CLASS W. (T) T.A. RESERVE, OR OF AUXILIARY TO A.T.S. UNEMPLOYED LIST

A 338368

THIS IS TO CERTIFY that No. 14444 2334 Rank CFN.

Name CASS WILFRED RICHARD

Unit A.A. WKSP COY R.E.M.E. has been

relegated to* { Class W., Royal Army Reserve
Class W. (T) T.A. Reserve
Unemployed List, A.T.S. }

* { for a definite period
or
for an indefinite period } from 7 MARCH '46 to

(Space for Unit's stamp)

7 MAR 1946

_____ Commanding
COMDG 2nd. A.A. WORKSHOP COMPANY. R.E.M.E

Station ARMINGHALL, NORWICH.

* Delete whichever is inapplicable.

(GV701) Wt.32170/3763. 5,850 Bks. 11/44. B. & S. Ltd 51-846.

Date 7 MARCH '46

(See NOTICE at back.)

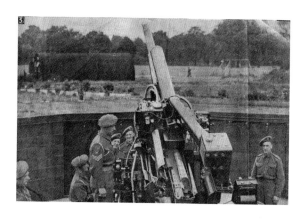

Glasgow's Maryhill Barracks was deemed unliveable as far back as 1898, and condemned to demolition in 1913, until the outbreak of the First World War granted it an ill-deserved reprieve – at least according to mess-hall rumour. The same thing happened in 1939, when the crumbling buildings were pressed back into service yet again. I arrived in the bone-deep chill of November to a place that even Victorian soldiers had despised, where we were crammed 150 men to each room with far too little air to go round. I'd walk from the thick fug of the barracks out into the freezing Glasgow winter in clothes that didn't fit my small stature, carrying a rifle twice my size, with a sergeant shouting at me to carry my pack into the river Kelvin. It's no wonder the nickname for the soldiers stationed at Maryhill was 'Hell's Last Issue' – this place was the absolute pits.

Early on in my new Army career, the brutal living conditions, the relentless orders by bastard Army sergeants, and the early-morning wades across the frozen river took their inevitable toll. My mind's determination to fight the war was no match for my body's determination to express its strong distaste for the Maryhill Barracks lifestyle. Pneumonia rapidly turned to double pneumonia. Fortunately, there was an effective new cure, as the chemical company May & Baker had recently concocted

the 'M&B' – a wonder-drug against pneumonia. In 1942, it cured Churchill; in 1944, it saved a lion from the Royal Circus. But apparently it was too valuable for a lowly conscript like me, and instead, I was invalided out to let nature do her healing work.

The facility I was sent to was set in the midst of beautiful Ayrshire countryside. At the recuperative hospital they took good care of us, fed the soldiers well, and generally made us as comfortable as they could. Despite having come close to death from my illness, I couldn't help but feel a little bit of a fraud: I was surrounded by men returning from the front lines with gunshot and shrapnel wounds; men arriving from Europe with no legs. So while I must admit to eating those hearty meals, looking out the windows at this beautiful peace and occasionally thinking, 'Oh, dear – I'm getting better!', by the time I was well I was ready to get back to work for the war effort.

Engines of War

Fortunately, it was then that the Army realised I had certain skills that could prove useful even if I perhaps didn't have the stature – or, after the pneumonia, the physical fitness – to hit the front lines. By 1944 it was obvious that the war would be won by technology, not brute force. In the previous year, new radar and radar-jamming technologies, code-breaking efforts, and weapons such as the

bouncing bomb had shown the British which way the wind was blowing. And by the time the V-1 and V-2 buzz bombs began raining on London, the war was being fought in laboratories as much as in Belgium or North Africa.

Once I'd recovered from my illnesses, I went on a low-grade training course in Bradford (without the brutal sergeants!) that included a national mathematical aptitude test in which I came top – which would have been a real surprise to my maths teacher back at Frensham Heights. That helped to ensure that, rather than carrying a pack through a frozen river, I was sent to Bolton for three months of intensive engineering classes at an Army technical college.

It was at that college that I began to come into my own. Until Bolton, I'd always thought of myself as a naturally late developer, for whom effort and application lay somewhere in the distant future – well, three months of engineering classes taught by bellowing Army sergeants changed that! And I was suddenly thrust into the front lines of the tech battle: I learned everything from the basics of electronics to the ins and outs of the first computers, and all in an environment that was supremely competitive, everyone thirsting for more and more knowledge.

Everything we were taught at Bolton would have an impact on my later interests, passions, and businesses. But the most important lesson I learned was how much I didn't know. I thought I knew all about engineering – I knew nothing. I thought I was interested in electronics – I knew nothing. Bolton made me understand the limitations of my knowledge, and made me want to push those limitations for the rest of my life.

This intense schooling in engineering had another knock-on effect that would follow me throughout my entire post-war career. After the three months of training, I was given an assignment as a private in the Royal Electrical and Mechanical Engineers (REME). I was sent to Clacton-on-Sea to work with a Royal Artillery anti-aircraft battery, one of the groups of massive anti-aircraft guns that lined the east coast of Britain shooting down German buzz bombs and airplanes. These guns were amongst the first to be sighted by computers, and it was my job to keep those computers running.

It was an intense and challenging environment in which to find myself, and I grew up in a flash. I was a lone 19-year-old REME private in charge of all this new technology for scores of guns and living in a group of about 400 men, most of whom didn't understand what I was doing there. But because I was REME

and they were Artillery, a funny thing happened: I wound up reporting to no one. It taught me that it's quite useful not to have a direct boss – something I've stuck to as often as possible throughout my career, and, indeed, my life.

I had previously thought the Army would be about trying to kill the enemy, but at Clacton I had to focus all my electronic knowledge on stopping our own men from killing themselves. The guns may have been high-tech, with computer-guided trajectories, but the men working them still had to set the fuses. And, illogically, you could actually set the fuse so that the round blew up while it was still in the gun. I invented a safety device that made that impossible. It probably didn't help the gun's efficiency, but it stopped you from blowing yourself up – which seemed rather more important to me at the time!

Bolton had at least one other lifelong impact on me. After leaving the college I was told that it was too dangerous to have as obvious and prominent a German-Jewish name as 'Cassirer'. One of the possible assignments I could have been sent on was to go into Germany with the ack-ack batteries – the anti-aircraft guns. Anyone potentially heading into combat with a German, Japanese, or Italian name was told to change their name; it was thought

Anti-aircraft guns at Clacton-on-Sea: "The tiny, makeshift shacks next to the guns were where we spent most of our hours on duty."

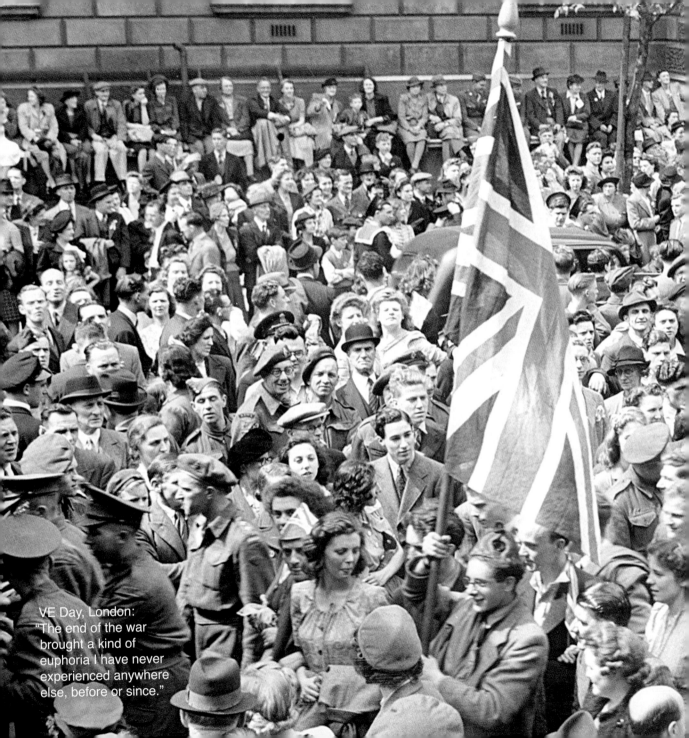

VE Day, London:
"The end of the war brought a kind of euphoria I have never experienced anywhere else, before or since."

that any personal detail that revealed our original nationality would make us extra vulnerable to capture and ill-treatment from the enemy. And thus did Eric and I both lose the telltale last two syllables of our surname to become simply Mr Cass.

It wasn't a difficult decision – I had already long ago ditched the name Wolfgang in favour of Wilfred, and I felt myself to be almost entirely English by now. A 19-year-old in the throes of war doesn't think too long or hard about such things, and besides, people in England had been mispronouncing and misspelling Cassirer my whole life! But my father wasn't pleased and, today, my children somewhat lament the loss of that name and its rich associations.

Peace Puzzle Most of the time, keeping on top of the guns' computers was a 24-hour-a-day job in Clacton. But every few weeks I would get a chance to head back into London for a night or a weekend – to visit family, of course, but also to enjoy the after-dark pastimes of a soldier on leave.

Paramount amongst my wartime nightlife options was the Windmill Club. It was one of the first London strip clubs, and had the additional selling point that, according to management's slogan, it "never closed". It may seem odd today, but at that time the

women at the Windmill weren't allowed to move – I'm reliably informed that their modern counterparts have a somewhat different policy! But my most vivid memory from the Windmill Club is not of the statuesque ladies. It concerns instead the night when I ran into someone I knew rather well in the audience: my father. We were both more than slightly embarrassed, and for the rest of his life we never spoke of it again.

Everything in wartime seemed to move to an accelerated timetable, and boys became men overnight. By 1945 I was promoted to REME Sergeant and was sent to Leicester Technical College to teach what I had learned so far to the incoming students, helping to produce more computer-ready operators for what was now a full-blown war of technology. But the war only lasted a few months longer – before I turned 21 years old, I found myself standing in front of Buckingham Palace in an ecstatic throng of people celebrating victory over Japan and the war's end. It was an amazing experience, with men jumping in the air and women climbing all over us: a kind of pure euphoria I've never experienced anywhere else, before or since.

But the war's end also meant the *real* university students came back into the classes I was teaching at Leicester, and they knew a hell of a lot more than I did! Fortunately, my time at Modern

Telephones meant that my papers said I was a telephone specialist – a 'Class B Release'. After the war, the country's communications infrastructure was in bad need of upkeep and upgrade, and so, as a 'specialist,' I was given early release from the army and was drafted into work. With just one year of phone work under my belt I was made a senior design technician in a new Telephone Rentals Limited experimental laboratory in Knightsbridge.

But while my 'specialism' made for a promising career, I knew that if I was really going to get into electronics, I'd need more education. First came a trip to New York City, where I worked briefly with my cousin Gerhard in his uncle's Photovolt assembly factory. Upon my return to my family's Putney flat, I knew that I needed formal schooling, and enrolled at the Regent Street Polytechnic College in a course in engineering and electronics.

Regent Street was a difficult decision to make. Like most of my classmates, my army time meant that I was late getting started on a career, and dedicating four years to education at the age of 22 seemed a risky decision at the time. But it also meant that everyone in my classes was determined to learn as much as they could, as quickly as they could, and no one was going to hold us back.

Every day, I would pedal my bicycle from Putney to Regent Street and spend all day in classes competing with my fellow students. If a teacher wasn't performing up to our high standards, we'd go straight to the principal and have him replaced. I came home exhausted from the cycle ride, and sat down to three hours of homework each night. No girlfriends, no parties, nothing but intensive learning – but, looking back, I'm obviously very pleased that I did it. Regent Street provided me with the second stage of learning to think: learning to work hard at the problems in hand, thinking sideways, thinking differently.

In 1951 I passed my exams with flying colours, earning a Higher National Diploma in Telecommunications. I became a member of the IEE (Institution of Electrical Engineers) and, subsequently, a Fellow of the IEE (FIEE).

There was a fellow in the year above me at Regent Street Polytechnic named Don Fisher. We liked and respected each other, and when Don graduated he got an excellent job as Chief Engineer at Pye Ltd., based in their Radio Works in Cambridge. Luckily, Don thought I would make a good addition to his team and encouraged me to apply for a job at Pye as soon as I graduated.

So it was that on 6 June 1951, I received a letter saying that my application for employment had been considered and approved by the Chief Engineer. My starting salary was £375 per annum, with a cost of living bonus of £50 a year. This was a good wage for a young bachelor, equivalent to about £35,000 today. So I packed my bags, said goodbye to my parents, and left to begin a new life in Cambridge.

CHAPTER 5: MY GREAT INVENTIONS

Plugged In

According to family legend, my great-great-uncle Isidor Cassirer owned one of the first telephone systems in Berlin. He had it installed at his timber and pulp factory. Visitors were dumbfounded by the fact that he always seemed to know they were coming before they reached his office at the other end of the compound. Of course, he had arranged for the guard at the gate to telephone ahead and tell him who was on the way.

There is no doubt that I inherited Uncle Isidor's delight and appreciation of new technologies. All my life, I've been what technologists call an "early adopter" – from my first souped-up Märklin engine to my Sinclair radio in the 1960s, my Apple computer in the 1980s, and my new Nissan Leaf electric car, which arrived not long after my eighty-eighth birthday. I love finding ingenious new ways to solve problems with technology. It was a trait that helped me stand out from the crowd in my first real job, more than 60 years ago.

When I joined Pye in Cambridge, I started out working on radio design. In the 1950s, sturdy, British-made wireless sets like Pye's were built to last. One of the sets I helped to design hit the headlines over 25 years later, when firemen called to a house fire

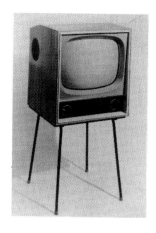

The Pye V4 television with original casing designed by Robin Day

threw a badly damaged Pye transistor radio out of the window of the burning building. It was discovered the next day in a heap of rubble, still playing.

But soon my attention was focused on the next big thing: television. TV broadcasting in the UK was only 15 years old when I started my career at Pye, and colour TV was still 15 years in the future. So I felt right at the cutting edge when I got to work on my first TV set, the Pye V4. It was a handsome affair in a walnut cabinet, with an angled glass screen designed to reduce glare. I worked on the electronics with Don, and I was very excited to see the first sets coming off the production line.

Once we began inspecting them more closely, it became apparent that they were not only handsome and exciting, but also a complete disaster.

At the princely retail cost of £48 10s 11d – more than my monthly pay packet at the time – the Pye V4 was more expensive than its competitors, but not because it was better. Unfortunately, although my diagrams and instructions were impeccable, the manufacturing process was riddled with errors and the sets

Pye V4 television
printed circuit board

were terribly unreliable and inefficient. I was certain that only radical action could effect the changes that were needed if Pye was to prosper.

Pye's factories at the time were spending 30 per cent more on producing their sets than other television manufacturers, and it didn't show! We didn't just need to reinvent the television set – we needed to reinvent the factory, too.

I took my plans to the chairman, a Mr C. O. Stanley. Luckily for me, he was a brilliant, creative Irish madman who totally "got" television – he was up to speed with all the latest trends, like colour technology and ITV. The culture at Pye at the time was one of dynamic innovation, often against the clock. In the run-up to the annual trade fair at Earl's Court, we would regularly work through the night for two or three days straight to get some new invention ready.

From Mr Stanley I learned that if you're the boss, you can create a really exciting atmosphere for your workforce on a daily basis. You need to be a bit of a showman and a bit of a politician. You can't just sit in your office, either – you have to keep your nose to the

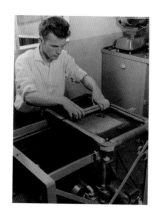

Silk-screening a Pye V4 circuit board

ground. Stanley would regularly pop up at my elbow in the lab and ask what I was doing. He didn't understand a word of what I told him, but somehow he knew what was going on.

So Mr Stanley agreed I should look into the very latest design and manufacturing techniques, with a view to experimenting on a modest scale at Pye. First, I set about researching the patents on the brand new technology of printed circuits, which were being designed in Austria and the US, but were not in general use in the UK. Then I spent a period in Chicago, where I visited the Chairman of Admiral Television to see what they were doing. (Admiral had supplied the United States Military with electronic equipment during the Second World War, and was one of the major television manufacturers in the '50s.) I also visited the Guardian Electric Manufacturing Company in the United States, where the Managing Director and the Chairman of the company gave me their time. Finally, on behalf of Pye, I purchased some patents lodged by a fellow émigré — the Austrian inventor Paul Eisler, one of the pioneers of printed circuits.

At the Pye factory in the early 1950s, hundreds of people were employed to build the television sets by hand, inserting

Assembly of radio
and television printed
circuits

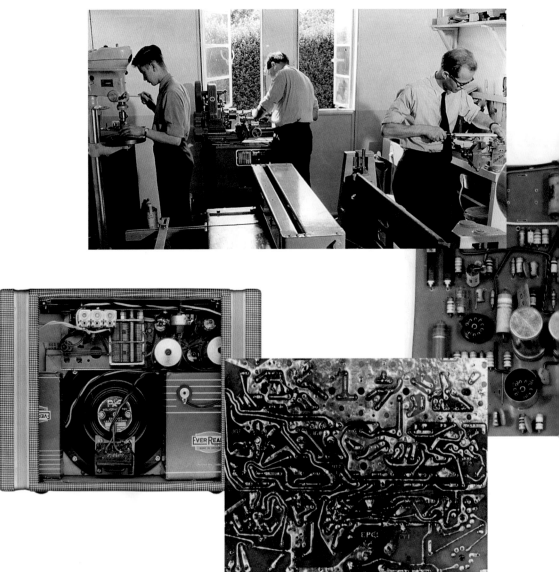

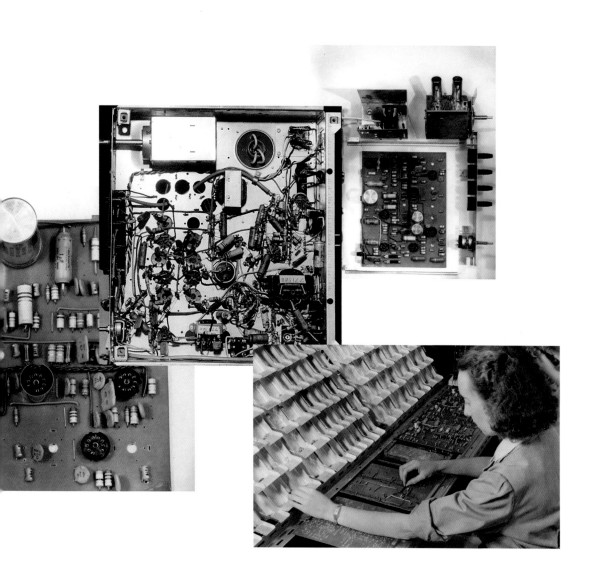

Richard Hadfield and Wilfred were lifelong business partners

components into the boards and using soldering irons to attach the wires that would connect them in the correct circuits. They were skilled workers, but it was a boring, repetitive job and over long hours, errors inevitably crept in. With printed circuits, the electrical engineer's design is printed onto a copper-coated board, then the superfluous metal is etched away with acid to leave only the 'wires' necessary to create a perfect circuit map. The beauty of this process is that it takes hundreds of human error risks out of the manufacturing process. Not only is the manufacturing process far more cost-efficient, but the resulting circuit boards are many times more reliable than any previous production process could achieve.

I took over a corner of the Pye television laboratory and set about designing my own version of a printed circuit. I spent many happy hours experimenting with molten solder, and dipping multi-components into the acid bath. The innovation I was working on was to simplify the process by dip-soldering the whole circuit board, instead of hand-soldering every separate connection – an advance that, once perfected, would save considerable time in the manufacturing process. My lab partners were not so thrilled by the resulting noxious fumes, and they threw me out. But I soon found a new home: a garage where I was allowed to design and produce a new laboratory for my experiments.

My somewhat smelly development work was sound, but science alone wasn't going to convince my bosses that printed circuits made economic sense. So I enticed my old school friend Richard Hadfield to come and work with me at Pye, to develop a business case and win over the company management.

Reunited for the first time since our Macirrer Ltd. bicycle repair days at Frensham Heights, Richard and I once again became a very effective team. In 1954, an article we wrote for *Wireless World* magazine, with the attention-grabbing headline "Dip-Soldered Chassis Production", won a *Radio Industry Council* award of 25 guineas. That sort of pocket money would have come in handy, as round about that time I traded in my beloved Vespa for a beautiful blue Austin Healey convertible, the better to show off a man-about-town.

Switched On

It wasn't all work, you see. Cambridge in the 1950s was the best possible place for a young man with an exciting job to spend his twenties. There were hunt balls, punting on the Cam, and all sorts of interesting young ladies. Freed from the constraints of army and education, living away from home properly for the first time, I was more than ready to have some fun. My parents were in their sixties by then, and although I went home to visit once a month or

While Wilfred lived in Cambridge, he befriended former Tate Gallery curator Jim Ede

so, I had the comfort of knowing that Eric was still living at home, working in the family business (Cass Electronics) and taking care of Mother and Father. I had money in my pocket for the first time, and opportunities to travel: my social life began to blossom.

John and Bill Grey were the ringleaders. The Grey brothers had inherited the family firm, a sporting goods manufacturer and outfitter, after their parents died young. They also had a beautiful house, and hosted all the best parties. Also part of the gang were several friends from Pye, mainly in the marketing department – I remember Peter Melville and James Miller in particular. There were glamorous girls, of course, but my time at Frensham had left me with high standards and none of the Cambridge set seemed quite right for me. The curse of growing up in a progressive co-ed school!

One character who made a great impression on me was Jim Ede, formerly a curator at the Tate Gallery and an important art collector in his own right. Jim was my father's age, and when I met him he was in the process of setting up Kettle's Yard, the combined home and art gallery that was to be his retirement project. He and his wife converted four cottages to house not only themselves but

Wilfred was inspired by visits to Kettle's Yard, the art gallery Jim Ede established in his Cambridge home

also their world-class collection of avant-garde art. I visited Kettle's Yard frequently, guided by Jim Ede and, perhaps, the ghosts of Cassirers past.

Growing up, my parents' house had always been full of beautiful objects – furniture, Meissen ceramics, books – but nothing like this. Hans and Edith were not greatly interested in contemporary art, so it wasn't until I was grown up that I discovered the extent to which promoting and collecting cutting-edge modern art ran in the family. Back in Berlin, my great uncles Paul and Bruno Cassirer had been pivotal figures in the Berlin Secession – an iconoclastic movement that broke away from the art establishment to champion new trends in art and literature in the first years of the 20th century.

As I have mentioned already, Paul was one of the earliest patrons in Germany of Impressionist painters like Munch, Cézanne and van Gogh. His cousin Bruno Cassirer was a publisher of important works on art and aesthetics. I knew Bruno in my youth – after he fled Nazi Germany and settled in Oxford with his family, my mother used to take me for violin lessons with his daughter, Agnes. So without realising it, I spent a lot of time as a child around one of the most important figures from the Secession.

But it wasn't until I met Jim Ede that I encountered for the first time a subsequent generation of radical artists, in the form of works by Ben and Winifred Nicholson, Henry Moore, Barbara Hepworth and many more. I was an instant convert. Of course, on my Pye salary I had no thought of collecting art myself; but a seed was no doubt planted during those convivial afternoons at Kettle's Yard.

My own domestic situation at the time was far less aesthetically pleasing, although very comfortable. I lived in a succession of digs close to the factory, with a couple of interesting landladies. One, a widow, was rather sweet on me, and pursued me with gradually decreasing subtlety. The other looked after me like a son, but was very strict: visiting girls were only allowed in the downstairs parlour for light cuddling, and had to be out by twelve o'clock. Ah, the old days!

One of the girls she chased out at midnight was Jean Thompson-Forbes, a young English rose from rural Dorset who was junior secretary to the Chairman at Pye. I was smitten: she was dazzlingly attractive, vivacious and stylish, with a great line in glamorous hats. We were chalk and cheese, though. She was bafflingly interested in horses and all sorts of country pursuits, while I was a city boy. Where I was quiet and reserved, she was

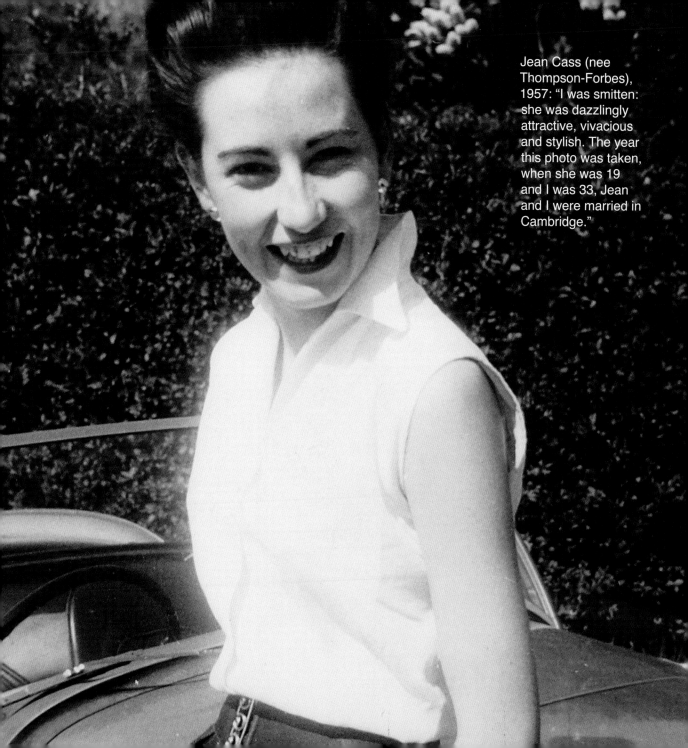

Jean Cass (nee Thompson-Forbes), 1957: "I was smitten: she was dazzlingly attractive, vivacious and stylish. The year this photo was taken, when she was 19 and I was 33, Jean and I were married in Cambridge."

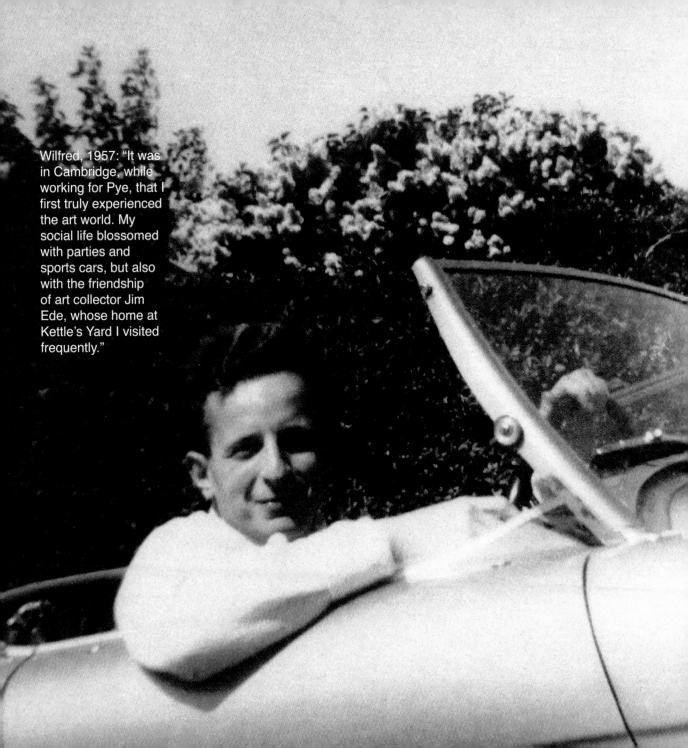

Wilfred, 1957: "It was in Cambridge, while working for Pye, that I first truly experienced the art world. My social life blossomed with parties and sports cars, but also with the friendship of art collector Jim Ede, whose home at Kettle's Yard I visited frequently."

voluble and loved company. But to a young man in love, all these differences seemed nothing but fascinating. I couldn't get enough of this gorgeous girl.

The management was not keen on workplace romance, but I was undeterred. I soon persuaded Jean to accompany me on a summer holiday to Bellagio, with the promise of rooms at the best hotel, The Grand. On the way we stopped in Reims and, to my not-too-great dismay, could only find a double room... The rest is history. Jean and I married in Cambridge Registry Office in 1957, with friends and Jean's grandmother present.

My parents didn't attend and nor did Jean's. My father told me he thought I was making a mistake: Jean was not Jewish and only 19. I imagine Jean's parents thought the match to a 33-year-old man of German Jewish origins equally unsuitable.

Don't Rock the Boat

Meanwhile, my career had also been attracting its fair share of controversy. The new printed circuit televisions would be cheaper and more reliable, but manufacturing them would only need a fraction of the labour required to make the old-style sets. Many of the staff at Pye were understandably sceptical about an innovation that was certain to cost them their jobs. On the other hand

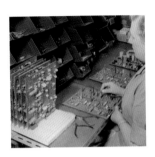

Before the introduction of printed circuits, TV circuit boards were hand-soldered

Mr Stanley, the mad Irish chairman, was very interested in my plan to make more money for his firm! Unfortunately, despite being a brilliant businessman, he suffered from alcoholism, and periodically disappeared to 'dry out'. The trick was to catch him at the right point of the cycle, after he got back to work and before the drink took hold again. I chose my moment, and presented my itemised Production Plan for the second version of the V4 Television Receiver.

As part of my proposal, I stipulated that I needed a new workforce of apprentices whom I could train specifically for the work at hand. If he gave me staff from the old factory, already skilled in the old manufacturing methods, it would be much harder to keep my project moving forward the way I wanted. Looking back, it seems a bold move for such a young man. But industry was evolving in leaps and bounds, and my post-war generation was hungry for progress. I could see so clearly what was wrong with the old ways, and nothing but a wholesale fresh start seemed enough. What's more, there is something in my nature that inclines me always to work problems out from first principles. It is a trait that was further nurtured during my time at Frensham Heights, and it survived my wartime experiences undented. By the time I got to Pye, it meant that I was willing to build a brand new factory and train a brand new workforce in order to build a new TV set.

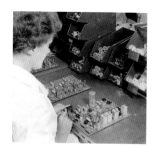

Wilfred saw that these methods introduced errors into the process and persuaded Pye to let him experiment with printed circuits

On Mr Stanley's orders, I was given a large building on the Pye premises to turn into my factory. I also won that new workforce I felt I needed, now comprised of fresh-faced apprentices ready to train up on printed circuits and dip-soldering. The product – the first 100% printed circuit television in Britain – was successfully launched to the market as the "Continental 17" in 1957. Advertising material from that time trumpets the printed circuit innovation – "Not only different, but more reliable…a better TV than you have ever known before."

Of all the new things I've tried in my career, this was the one that had by far the greatest impact on people. The work we pioneered at Pye – new, cheaper methods of dip-soldering printed circuits – helped to change the face of consumer electronics. Today, every electronic device has a printed circuit in it. But back in the 1960s, these innovations were not universally popular amongst the senior management at Pye. The new system threatened their jobs, and they didn't all have C. O. Stanley's ability to see the bigger picture: that this was the way TV manufacture was heading, and that if they didn't adapt they would all go down together. Unfortunately for Pye, on this occasion the visionaries lost to the traditionalists. With the Chairman back in the drying-out clinic and his son in charge, they had free rein. Printed circuits

were out. They closed down my experimental factory, and I resigned the next day, pre-empting the firing that I knew was on the cards.

Some nine years after I left Pye, on 11 November 1966, an article appeared in the *Financial Times* reporting that the company was in serious financial difficulties. Mr J. Stanley, the former Chairman's son who was instrumental in virtually sacking me, had to explain his own ousting by the board. "The root problem which has faced and continues to face the group is that it costs Pye several pounds more than other manufacturers to produce a comparable TV set. This affects the profitability of every operation in the domestic field." In 1967, the crippled company was taken over by Phillips. I have to admit the downfall of Pye afforded me a certain satisfaction. If they had followed my advice and persevered with printed circuit technology – an innovation that all their competitors adopted – the company would probably have remained financially viable.

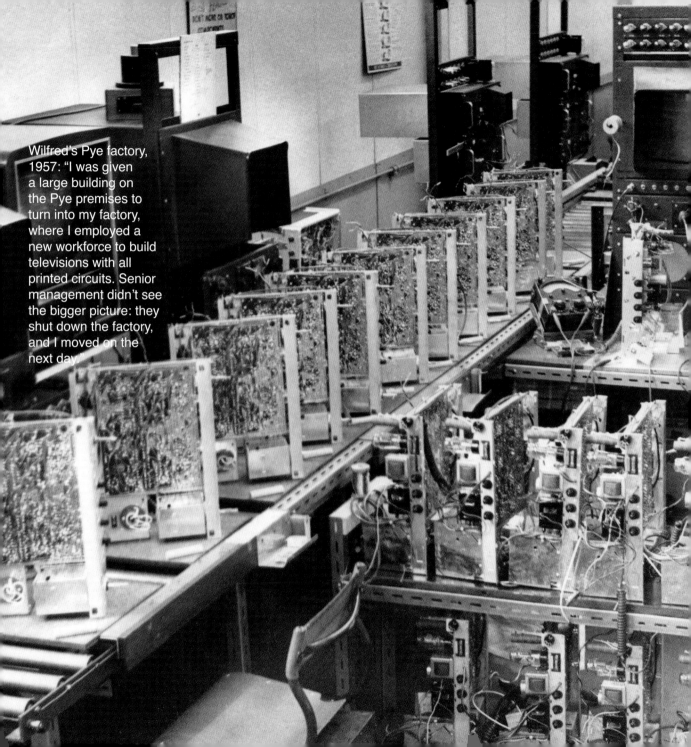

Wilfred's Pye factory, 1957: "I was given a large building on the Pye premises to turn into my factory, where I employed a new workforce to build televisions with all printed circuits. Senior management didn't see the bigger picture: they shut down the factory, and I moved on the next day."

CHAPTER 6: TROUBLE SHOOTING

Finding My Niche

The year I was born, 1924, witnessed the death of my great-great-uncle Julius Cassirer, the man who oversaw the establishment of the Cassirer dynasty in Berlin. It was an empire financed by the family's industriousness: by the Breslau textile factory operated by my great-great-grandfather, Dr Louis Cassirer; by his brothers' timber businesses across Germany, Poland and Czechoslovakia; and by their canny investments in the construction of a resurgent Berlin – newly established in 1871 as the capital city for the German Reich.

In Berlin, Julius Cassirer used his millions to fund his nephews Hugo and Alfred in building the Dr Cassirer & Co. cable works – the Charlottenburg factory that eventually became my father's. Rubber encasement, as made by Dr Cassirer & Co., was a vital new advance in electrical-cable technology. It did everything from insulating the power sources of standard appliances to making radio and communications technology reliable by cutting out interference.

I didn't realise it at the time, but my work with printed circuits at Pye was very much a continuation of a Cassirer family trait: envisaging new technologies, and new ways to make established technologies work better.

But the Cassirer knack for business isn't only about creating new technologies; rather, it is the entrepreneurial eye for seeing possibilities where others see risk. Part of that is being technological "early adopters" – whether that's imagining the future of electrical cables or the possibilities inherent in printed circuits. But part of that is also investing in timber just before a building boom in turn-of-the-century Berlin – as Julius' brothers, including my great-great-grandfather Dr Louis Cassirer, did – or falling in love with Impressionist painting before anyone else in Germany had. Or it's realising that children's education could be something completely different, as Louis' niece and nephew did in establishing the Odenwaldschule. Or, indeed, seeing that Pye doesn't just need new technology, but a whole new factory system, if it's going to make a turnaround.

The main thing I had learnt from my career so far was that I didn't want to work in the stifling hierarchy of a large manufacturing firm. I had an instinct for business and a lot of experience for my age, but at Pye I had to jump through hoops to get people to listen to my advice, only to watch them ignore it in the end. I made up my mind: I was going to work for myself, selling my expertise and analytical thinking abilities to companies that were prepared to follow my recommendations.

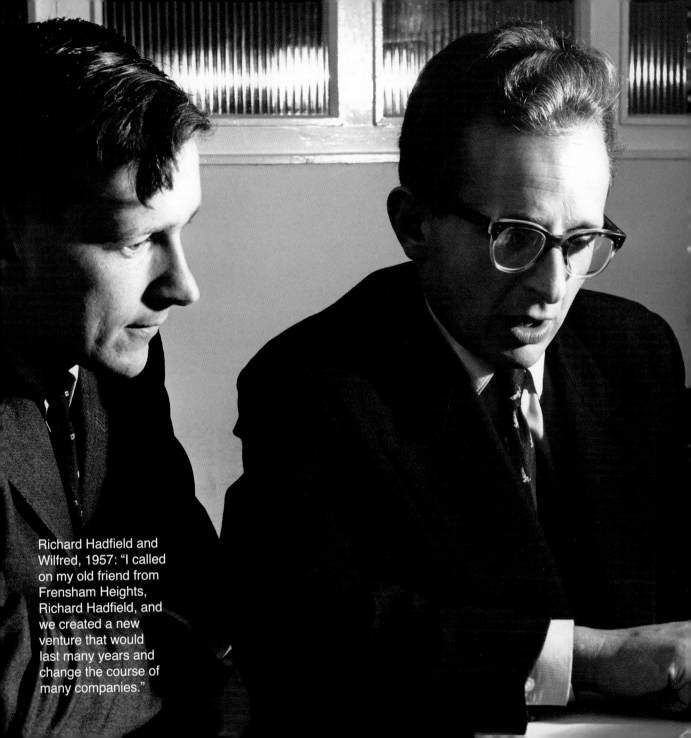

Richard Hadfield and Wilfred, 1957: "I called on my old friend from Frensham Heights, Richard Hadfield, and we created a new venture that would last many years and change the course of many companies."

The bosses at Pye were not generous when I left the company, so Jean and I started married life with very little money. Generous as ever, Jean bought me an electric shaver with the last of her cash. No doubt I looked far more dapper and confident than I felt! With my freshly shaved face, and spurred on by a desperate need for gainful employment, I almost immediately secured a consultancy assignment with a company in Romford, Essex. The client was Regentone, a relatively new television manufacturing company that shared my enthusiasm for printed circuits. However, the company's stock control was a shambles, and needed total reorganisation – a job greater than one man could handle! So I called on my old friend from Frensham Heights, Richard Hadfield, who joined me to take on that task. We called our new venture Cass McLaren (Richard's middle name), a joint effort that would last years and change the course of many companies.

Our working partnership was as close as ever. Richard even moved in with Jean and I for a while, which was convenient for the workmates but not ideal for the newlyweds. Nevertheless, Jean was incredibly adaptable and accepting of all the changes to our circumstances, and we got on pretty well with the business of being married; well enough, at any rate, to welcome our first child, Mark, in 1958. If Richard hadn't already moved on, his motivation

Promotional brochures
for Rotawinder – the first
company Richard and
Wilfred set up together

enmeshed in details

Right: Wilfred Cass
Below:
Richard McLaren Hadfield

By getting management to check on their own activities many problems can be eliminated.

Cass McLaren
prospered in the 1960s

would have been sharpened by Mark's attempts to make as much noise as possible for the next several years! Jean was a great mother, and held the fort very capably at home while I worked all hours to get the business off the ground.

As Cass McLaren's contract with Regentone was nearing an end, Richard and I got a job with a Mr Weinstock (later Lord Weinstock of General Electric Limited), who was running large television companies in Wales. Mr Weinstock hated consultants, but he hated wasting money even more, and we managed to persuade him that we could reduce the manufacturing costs of coil winding by a minimum of 30 per cent. (Coil winding, the process of making an electromagnetic coil, was integral to the manufacture of several aspects of a television set.) Richard and I set up the Rotawinder company and developed machinery that ended up saving him nearly 50 per cent; he was a good customer for many years.

Here's what I found: consultancy is easy. The company thinks its problems are unique and highly complex, but the experienced outsider sees most of the game from the outset. The workforce knows what's wrong, but they're bored. (Hence the distracting, and often interestingly tangled sex lives that one tends to observe

in a manufacturing company!) If you can get them to concentrate and simply tell you what's not working, they will. So I learnt to speak to everyone without worrying about management structure or hierarchy.

Secondly, I realised how many problems stem from managers trying to protect their own jobs and minimise internal competition, so when I needed to work as part of a team I always tried to recruit people who were better and cleverer than me. And thirdly, I discovered that secrets are dangerous: the company grapevine will always assume the worst, so everyone might as well know the truth at all times.

Cass McLaren prospered throughout the 1960s, taking on numerous short contracts alongside our two major projects: Rotawinder (which was really Richard's domain), and my work with Gunson Sortex Ltd, the leading manufacturer of industrial sorting equipment. But consultancy was not really my game – I was sick of writing endless reports, and coaxing reluctant clients to see things my way. I really wanted to be the boss and get on with the business of steering the ship, no questions asked. It was at Gunson Sortex that I got my first taste of management, thanks to a brilliant but often infuriating Hungarian named Paul Balint.

Seeds of Change

When I arrived at Gunson Sortex, the company was in a mess. It had taken over a large factory in London's East End to build its patented seed-sorting machines, attempting to fill nearly a year's backlog of orders. But rather than hiring new employees experienced in manufacturing, engineering, and factory operation, the company had simply transferred employees from one of its seed warehouses in order to man the factory.

It became clear that what was required was a total revamp of the process by which the factory was managed, as well as a total redesign of the machines. The man in charge was Paul Balint, chairman of Sortex's parent company, Gunson Seeds. He understood that the company's machinery needed to be overhauled, but wasn't convinced that the labour-management side of things was in the same bad shape – despite having a factory full of employees with no knowledge of manufacturing (including a number of members of Balint's extended family straight off the boat from Hungary) and a hopeless factory manager! After the first week, he tried to sack me on the grounds that things were worse than ever before. But he backed down and grudgingly agreed to give us more time. After battling for a few weeks, I went to him and suggested that I should take over the total management of the company: I wanted a free hand to do what was necessary.

Wilfred's first taste of full-time management came at Sortex

Balint very reluctantly agreed. But for the next six months, he called two or three times a day, querying every bill and every decision. Eventually I told him that I would like to be left alone to run the company and only meet with him on a quarterly basis, when I would report back with all the figures. It didn't quite work out like that, but I was largely left alone as the business grew and started making big money. In the end I stayed for almost seven years, and helped turn the business around, from a yearly loss of half a million pounds to an annual profit of £6-7 million. I even got to like Mr Balint, who was probably the toughest man I have ever met.

Balint was a big man, both in stature and personality. He could be very intimidating, and very funny too. He became an important mentor, from whom I learnt an amazing amount – not just every Hungarian joke going, but also how to progress business on a daily basis and to never take no for an answer.

Balint inadvertently taught me a few surprising tools of the trade, too. For example, although he spoke perfect English, he usually gave orders in deliberately obscure Hungarian-inflected phrases. What he had worked out is that people very often perform better if they are given only partial instructions, because they have to use their initiative and work out the rest of the solution themselves. It's a technique that has proven its worth time and time again in my own career.

Sortex brochures, circa 1960s: "Cass McLaren took on numerous short contracts alongside our two major projects: Richard's was Rotawinder; mine was Sortex, the leading manufacturer of industrial sorting equipment."

SORTEX

Packing and despatch

Wherever possible, Sortex equipment is sent all over the world by air freight. There are many advantages in doing this: almost immediate delivery, fast handling and a wide choice of conveniently placed airports.

Because careful handling by air cargo can be relied upon, valuable Sortex electronic equipment is fully protected.

In specially designed lightweight cartons. The packing is fast and packaging costs more than compensates for the air freight costs.

If shipment by sea is necessary, qualified packers are used and all machines are packed in specially made wooden cases for maximum protection.

Inspection

Customer confidence in the greatest possible reliability is absolutely crucial to all users of Sortex machines. As a result, at all stages of manufacture there is an emphasis on high-quality workmanship, supervision and inspection. Every component and sub-assembly is tested electronically and mechanically.

On completion every machine is subjected to continuous running under operational conditions for several days, twenty-four hours a day. This period ensures the reliability and stability of each machine despatched.

Range of manufacture

Sortex electro-optical sorting and sensing equipment is used mainly in the food, agricultural, chemical and mineral processing industries. The range includes:

Optical Colour Sortex which automatically inspect the surface colour and shade of a commodity and reject unacceptable items or divide items of a different colour. The size and arrangement of machines vary according to the commodities being handled.

Air Separators which grade products into two or three weight separations.

Size Graders which automatically grade items according to length or diameter.

Colour controllers which electronically scan a continuous strip feed or flow installation and give warning of colour variation.

Specialised Sensing Equipment which inspects products for x-ray and other techniques beyond the visible light range.

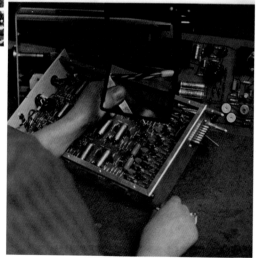

Southwood House in its Heyday.

9

Southwood House: After a fire, the modernist Southwood House Estate took its place

There was no use complaining to Mr Balint. His life had not been easy – like my own family, the Balints had fled the Nazi regime, moving to England from their native Hungary. His father and two brothers made it out, but his sister and nephew died in a concentration camp. Whenever I came to him with some new thing that was going wrong in the world, he used to say, "Believe me, you will get used to it soon enough", or "Stop treating me like a lavatory. I hate it when you pull my chain." A number of his relatives worked in the business, some more effectively than others. I often had cause to criticise the performance of one cousin or another, but he would reply, "Well, you can't re-fuck people." That usually shut me up.

In 1964 Jean, Mark and I moved into a brand new house in Highgate, where our daughter Nicola (known as Nikki) was born. In fact she arrived a little too promptly, a few days before the concrete floor had been laid!

The Southwood House Estate was a delightful place, designed to a unique triangular plan on the site of a former 18th century house and its grounds. The 40 or so houses were home to a wonderful mix of art curators, architects, lawyers, financial people, musicians,

Southwood Lane - A March of Houses.

15

Southwood House Estate, where Wilfred, Jean, Mark and Nikki Cass lived

and so on, some of whom are still friends of mine today. The designers laid out the development in such a way that we could go straight out of our houses into the private communal gardens, so it was extremely sociable. It was a great place for young children to grow up and there were always fantastic parties going on.

One of the first couples to move into Southwood was Klaus and Gretel Hinrichsen. Klaus was an art historian from another famous German family – being half Jewish, he fled to England in 1939 and was, in fact, interned on the Isle of Man like my father. There, he had been instrumental in setting up the "Hutchinson University", a communal space where creativity flourished in the internment camp, in particular the work of famed German immigrant artist Kurt Schwitters. Hinrichsen was a great collector of graphics and a connoisseur of art of every kind, including both African art and the Dadaists. Through my friendship with him, I developed a much wider understanding of art, including contemporary painters like Allen Jones, whose "Buses" were big news at the time. Klaus had an enviable life: his wife would bring him breakfast in bed, after which he would rise around midday and make his way round all the galleries, not necessarily buying anything, but always having a really good chat. As if that wasn't enough fun, the Hinrichsens also

ran a toy shop in Highgate Road. Perhaps I never really grew out of my love for toy trains and cars; at any rate, it was always great fun to visit.

Another couple that lived near us at Highgate was Timothy and Dawn Adès. Timothy is a prominent poet and translator of literature including the likes of Victor Hugo and Stéphane Mallarmé. Dawn is one of the premier art historians in Britain, and I'm certain when I think back that their presence had a big impact on my understanding of art and my connection to the intellectual world of London. Notably, Tim and Dawn's son, Thomas Adès, is probably the most significant composer of new music in Britain today – his work regularly performed all over the UK and around the world. Growing up in the vibrant artistic and intellectual life of Highgate certainly seems to have had its advantages! Most importantly, Jean and the children loved the easy sociability of the place, and made lots of good friends.

CHAPTER 7: BOSS FOR HIRE

Sorting Things Out

My years at Gunson Sortex passed in a flash. I was in my element, having assembled a very fine team of engineers that I worked with to develop a range of machines to sort almost every kind of foodstuff and material, from rice to diamonds. We marketed the machines internationally, so I was on a plane every second week, fitting in regular visits to our factories in the USA and South Africa too. The latter was our main market for diamond sorting machines, and we did very good business there.

Part of my sales pitch to the diamond mine companies was to offer to give them the machines for free in exchange for the rights to sort through the slag heaps outside their mines. Of course nobody took me up on it – everyone knew there were lots of diamonds in the slag heaps, sometimes more than were left in the mines! But it hooked them in, and I made plenty of sales.

It was in Johannesburg that I first met my cousin Reinhold Cassirer, who had settled in South Africa after fleeing Berlin in the 1930s and was married to the writer Nadine Gordimer. Reinhold followed in his uncle Paul's footsteps to become an art dealer; when I reconnected with him in the late '60s he was running Sothebys in South Africa. He told me they had a small sculpture for sale by Henry Moore, who was not very well known locally,

and he was not sure how much interest there would be. I looked at the piece – an early mother-and-child maquette – and loved it. I bid for it at the auction and got it for a ridiculously good price. It was my first major sculpture purchase. At the time, I could scarcely have imagined the vital role that Henry Moore and British sculptors in general were to play in my later life.

Another important trip around that time was a problem-solving mission to Japan. The Sharp company had copied one of our rice-sorting machines, virtually part for part, and put it on show at the Osaka Trade Fair at exactly half our price. How could Gunson Sortex, of the Whitechapel Road, take on the might of an electronics giant like Sharp, more than halfway round the world? I was heading to Japan to confront them, but without much hope – it seemed likely that the Sharp board would crush us.

There have been many times during my life when I've felt as though an invisible hand was at work, gently nudging me into the path of tremendous luck. On the plane going out to Osaka, I found myself sitting next to Sharp's head UK agent. Flying was a more civilised business in those days, and the fraternity of the first-class cabin went a long way. I told him my side of the story, and he was horrified that Gunson Sortex's inventions had been copied in such

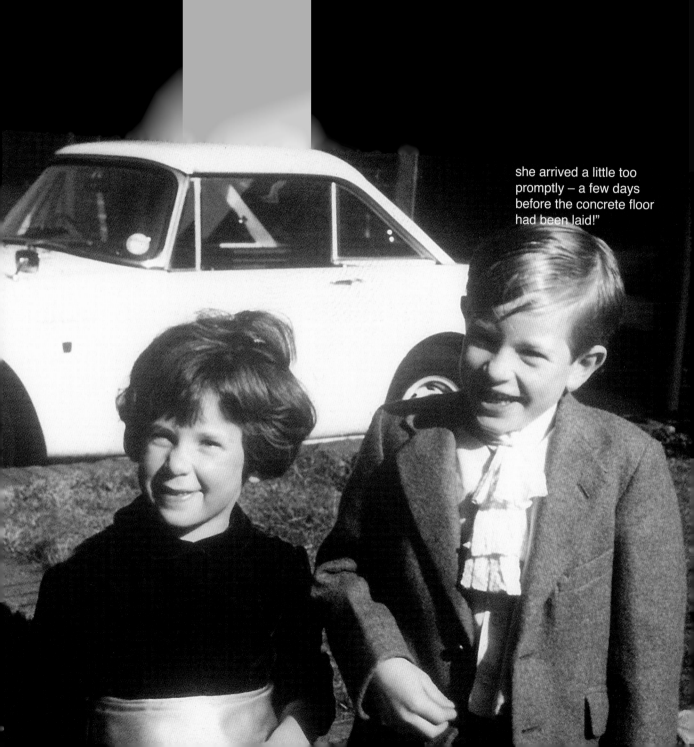

she arrived a little too promptly – a few days before the concrete floor had been laid!"

Sortex rice-sorting
machine

a way. During the remainder of our 11-hour flight, we worked out a joint strategy that we hoped would shame the Sharp board into reversing their decision to compete with Gunson Sortex. It all went exactly as we had planned. Sharp withdrew the prototype rice-sorting machine, and I found in their lab the very latest photo-electric products that we could use in future machines, which I was able to buy from them in great quantities.

Running a thriving business was exciting and rewarding to me: troubleshooting my way across the globe, and introducing more and more sophisticated technologies into the industry. But in one rather important way, Gunson Sortex was somewhat less rewarding. I had a wife and two young children to support, and despite years of success, my only compensation was a modest consultancy fee. I spent most of my disposable income at that time on family holidays – I was a big believer in making them really special, perhaps to try and make up for my frequent absences during the rest of the year.

It was my father who told me I was crazy to continue making a fortune for Paul Balint with no financial incentive for myself. I assured him there was absolutely nothing I could do to persuade Paul to cut me in. My father replied that he would take care of it – he

1960s promotional
materials for Colortune –
Wilfred's automated car
tune-up device – and
Sortex seed sorters.

Queen's Award for
Industry ceremony
(L to R): Wilfred, Ian
Mikardo, MP, Queen's
representative, Sortex
chief engineer.

**The Sortex Bichromatic
Sorter sees colours
you've never even noticed**

Sortex
1120 Range

**Mass
Production**

QUANTITY PRODUCTION AND REPETITION MANUFACTURE BY BATCH AND CONTINUOUS METHODS

Colour Sorting

Save you
on tune u
petrol v
Colortun

FIFTY "SORTEX" G32 MACHINES SORTING GREEN COFFEE AT SAU PAULO (BRAZIL)

...'s are specialists in electronic colour separating for the food, con-
...ary, seed, chemical and mining industries.

...amples of all your commodities for free tests on "Sortex" machines.

...enced technical salesmen are also available without obligation to
...your products and make "Sortex" recommendations.

...men and installations

W. GUNSON (Seeds) LTD

...Department
...Dobson's Mill, London E.C.1 (England)
...Wharing Cross 0427. Inc. Telex: 26168 Answer
...our Economic Integrated Tender

GUNSON'S

SORTEX

...British and Foreign patents
...granted and pending

money

**The Sortex Monochromatic
Sorter - a new way to look
at light and dark**

Sortex
920 Range

THE COLORTUNE 2

THE PLUG-IN FOR PERFECT TUNING

understood men like Balint, who was, after all, the same age as him and from a similar business background. I agreed to give it a shot, and set up a meeting for the three of us – myself, my father, and Paul Balint.

Well, we had a hilarious lunch together. For more than two hours, Paul Balint and Hans Cassirer traded Hungarian stories for German ones. When we came to the end of our meal, Father was not a bit further on with negotiating my possible board membership or shares. As we left the restaurant my father, shaking his head, said, "You will never get a penny out of this man. I have met his type before and the sooner you get another job, the better it will be for you." I knew he was right, and immediately began looking for a new assignment and putting new management in place at Gunson Sortex to continue my work once I was gone.

One of the first business lessons I had learnt from Paul was that no one is indispensible. If anyone wanted to leave, he would assure them they were not really needed and let them go, however important they had been to the company. So I had no illusions about what his reaction would be when I told him I was leaving. Sure enough, he accepted my resignation and washed his hands of me.

However, to my great surprise, after three months of not speaking to me Paul got in touch to say that he would like me back. I said no thank you, but he did employ me for the next four years as a board member, paying me the same amount annually as before, but for just four visits per year: finally, a financial acknowledgment! The business continues to thrive; now under Swiss ownership (under the name Buhler), it is still based in East London and is still a major company in the food sorting industry.

Painted into a Corner

I didn't have to look far for my next management job. Richard Hadfield, my consultancy colleague and best friend since Frensham days, was heir to a venerable family paint business that had recently found itself in dire trouble. He asked if I could step in, with his help, to catalyse some change in the company's fortunes. So off I went to Mitcham, South London, where a vast paint factory awaited me. To my surprise, also awaiting me was the still-warm chair of the previous managing director. Disgusted by my appointment, he had quit the day before. I was shown into an office that seemed roughly the size of a football pitch. Left alone, I pondered what to do next. It was an amazing moment – I can still remember that feeling of suspended animation, half terrifying and half exhilarating. I had absolutely no idea what to do next. I called the secretary and asked her whether I had any appointments and

Hadfields
Acrylic Gloss
paint

open

Could a foxy new brand…

she said none, what were my wishes? I said I had none! I have often reflected since on how a person without any kind of experience can suddenly sit in a seat of great power; I think it gave me just a little taste of the way a new Prime Minister or President feels on his first day in office.

I decided there was only one way to begin: I would walk around the factory and talk to as many people as I possibly could. Most people were bemused, to say the least, but quite a few gave me views on what was wrong and this was really helpful.

Hadfields had once been a considerable power in the paint world. Historically, Hadfields' high-quality gloss paint had the pub market pretty much cornered, as it was immune to tobacco smoke discoloration. Their sales pitch was that the quality of the paint demanded a price of £3 per gallon – which was all very well until ICI started to make a very similar product that sold at Tesco for £1 per gallon. By contrast, Hadfields had absolutely no retail distribution – in fact, we were known only in the trade. We were still the fourth-largest paint supplier in the UK, but the top three were all much, much bigger fish. Richard had already set about improving factory processes and so on, but we could see that this alone would not get us out of the hole. We needed to break

Hadfields
Acrylic Gloss
paint

sorry
closed

…save Hadfields paints?

through to the retail market, before we got swallowed up by one of our competitors.

I brainstormed with some of our customers and particularly with our in-house research and development lab (which was world-class), to see if we could come up with a new product or two that we could sell directly to consumers. I got really excited about one particular product that I discovered we had in the lab – a type of reusable putty that we had been selling to the aircraft industry. We could foresee any number of domestic uses for it, so we called it "Sticky Stuff" and trialled it on a mail-order basis. It was somewhat successful, but it needed more investment and better distribution. And, quite possibly, a catchier brand name, if the subsequent success of a near-identical product marketed by a competitor as Blu Tac is anything to go by!

Next in contention was an acrylic gloss paint that could be cleaned off the paintbrush with water, but would still be hardwearing and waterproof once dry. The lab boys were confident they could make it, so we engaged a sales manager and a sales force, along with some brilliant advertising people who advised on television marketing. It took some six months to get the product right, but we were ready to launch by September 1968.

Hadfields advertisements and press cuttings, 1967-1968: "Richard asked if I could step in to help his family's troubled paint business. As the Hadfields brand was unknown to retail customers, I enlisted an ambitious young design agency – Wolff Olins – to revamp our identity. The canny fox they came up with became a banner to rally around."

Hadfields Acrylic Gloss. Mitcham, Surrey. 01-648 3422

w about

roof

int eliminates

adfields
1840

therproof Wall Paint

greetings
ields
Chemicals.

tick these stamps on your Christmas

You won't believe it till you try it.

There isn't a drop of oil anywhere near Hadfields new gloss paint.

So now you can clean your brush under the tap. Without turps. Without mess. Just with water.

They call this remarkable paint Hadfields Acrylic Gloss.

And because it doesn't have an oil base, it doesn't have any of the other nasty habits that ordinary gloss paint has.

It goes on faster. Dries faster. Doesn't smell painty. Doesn't go yellow or fade.

The only thing it does have in common with ordinary gloss paints is it's hard, scrubbable finish.

Try some. You won't believe it till you do.

Hadfields
Acrylic Gloss

FOR THE NAME OF YOUR NEAREST STOCKIST AND A FULL COLOUR LEAFLET WRITE TO HADFIELDS (MERTON) LTD., WESTERN ROAD, MITCHAM, SURREY, CR4 3YG.

Hadfields
Acrylic Gloss

Hadfields
Paint and Chemicals.

Founded 1840

115

Hadfields
Paint and Chemicals

Snapping at the
competitors

As the Hadfields brand was totally unknown to retail customers,
I enlisted the help of a young, ambitious design agency called
Wolff Olins to revamp our corporate identity and make the name
more memorable. At the final meeting to decide the corporate
identity and design, I had to break the news to them after only
ten minutes that I absolutely hated it. Michael Wolff, who I
consider a genius, saw my dismay and said he would come back
with a totally new solution in two and a half weeks. He was as
good as his word, and it was brilliant. The canny fox that became
the company's emblem gave us a banner to rally around, and an
identity Hadfields could really relate to: small, agile, snapping
at the competitors, always getting out of trouble just in time.
We rebranded everything, from press adverts to paint tins to
delivery vans.

The fox designs won plenty of awards and really helped to put
Wolff Olins on the map. Sadly, the new waterproof paint was
not quite as foxy as we hoped. In the first few weeks it sold so
well we thought we would have to build another factory, but as
September went into October a really moist period started and
this wonderful paint just would not dry. It was back to the lab for
the R&D boys.

The Freemasons

Just as my time at Hadfields was coming to an end, I was approached by Warburgs investment bank to enquire whether I was interested in becoming the Managing Director of a venerable public company called Buck and Hickman Limited. It had been run by a family called the Twallins for many years, although recently without any sign of a profit. When I came on board in 1970, Old Man Twallin had just died, leaving the company to two sons, both in their seventies, who had never set foot inside it – a prospect which made at least one investor nervous enough to attempt a hostile takeover. The Ionian Bank, led by its Chairman Michael Behrens, had started to buy up Buck and Hickman shares, which were languishing at around £1, and Warburgs had been called in by the Twallins to try to stop them gaining a controlling stake and ousting the family completely.

Warburgs managed to broker a deal with the Ionian Bank: I would come in as Managing Director to put the company right and the Twallin family, although remaining on the board, would take a back seat. This provided for one of the strangest business relationships of my career, as the older Twallin brother was a Worshipful Master in the Freemasons, and the family's entire outlook was Masonic in nature. A strange world, indeed, for a nice Jewish boy to come into!

Buck and Hickman
imported and distributed
gear-cutting machines

Buck and Hickman were import agents for gear-cutting machines supplying the motor industry, but the company's main concern was the manufacture and supply of ironmongery – hand tools, nails, and household necessities of all kinds. Just like an old-fashioned ironmonger's shop, I quickly discovered that we owned a great deal of stock – everything from hammers to sealing wax – squirreled away in 20 large depots around the country, the main one being in Whitechapel. This London depot alone housed some 30,000 different unsold tools and items, some dating back to the Boer War. There were no part numbers, no proper stock control, and no computers. Stock was counted every year on cards that were sent up to the Chairman before he decided which stock figures were going to the auditors. It was not what you would call a watertight system – in fact it was hardly a system at all.

I set about digitising the stock, naming it, giving it numbers and then trying to arrive at a figure. With the new computerised stocktaking, we found ourselves in possession of £20 million in stock. This was not entirely happy news, because at that point, Buck and Hickman's valuation on the Stock Exchange was a mere £4 million. Anxious to avoid the accusation that we might have been misleading the market for the past decade, we wrote down the stock through various systems until we got to somewhere around £1.5 million – a much more manageable figure.

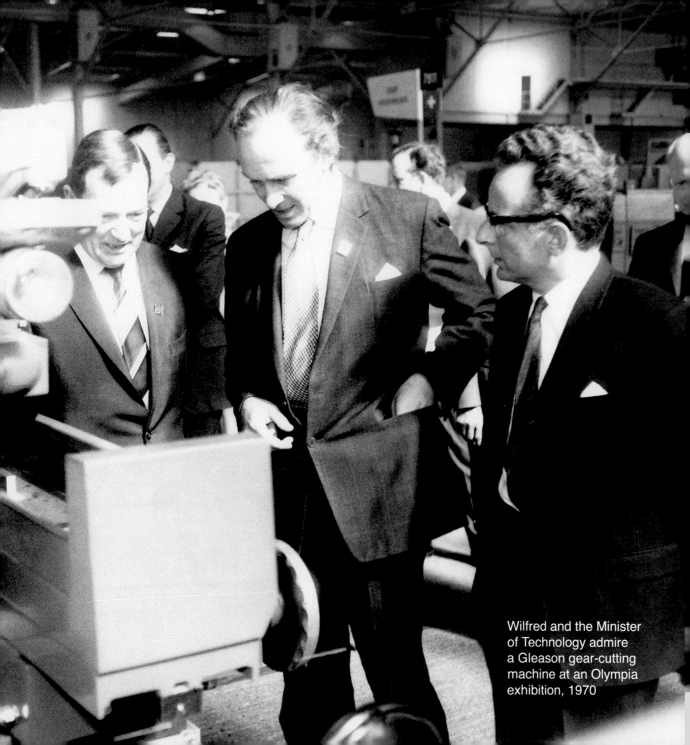

Wilfred and the Minister of Technology admire a Gleason gear-cutting machine at an Olympia exhibition, 1970

DEALS
Hickman VOL.1 NO.1

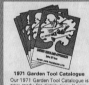

1971 Garden Tool Catalogue
Our 1971 Garden Tool Catalogue is now ready for distribution. It comprises some 28 pages of Garden Tools and Appliances all by well known manufacturers. A tear out discount sheet is incorporated.
Free on request.

Hickman

Buck & Hickman Limited
P.O. Box No. 74
Whitechapel Road
London E1 1EB

Telephone 01-247 7676
Automatic Answering 01-
Telegrams Roebuck Londo
Telex 888761 (Roebuck)

Telephone Ext
Our Reference
Your Reference
Date

...loyees.

...rey Sterling.

BOARD CHANGES

Following the acquisition of Buck and Hickman by Sterling Guarantee Trust Limited, Sir William Cook has kindly agreed to stand down so as to allow me to take the Chair. I am very pleased to inform you, however, that we will still have the benefit of his advice as he will be continuing as a member of the Board.

Mr. Wilfred Cass is relinquishing the post of Managing Director but will continue as a member of the Board in a consultative capacity to assist us in implementing policies that he has been largely responsible for formulating.

Mr. Peter Ford, the Director of Sterling Guarantee Trust responsible for the management of operating companies, will become Executive Deputy Chairman and will have overall responsibility for managing Buck and Hickman. Mr. Bruce MacPhail, Financial Director of Sterling Guarantee Trust, has also joined the Board.

Your new Board will, therefore, be as follows:-

 Mr. Jeffrey Sterling - Chairman.
 Mr. Peter Ford - Executive Deputy Chairman.
 Sir William Cook
 Mr. Wilfred Cass
 Mr. Bruce MacPhail

I am convinced that Buck and Hickman has a great future as a trading company and all of the members of the Board are looking forward to working closely with you to achieve this potential.

Telegrams: "Roebuck, London, E.1." Telephone 01-247 7676

Buck & Hickman Ltd. 2, Whitechapel Road,
 London, E.1.

W.R. Cass Esq.,F.I.E.E.
108 Southwood Lane,
LONDON. N. 6.

 6th May 1970

Dear Mr Cass,

 I am writing on behalf of my colleagues and myself to inform you that your appointment as Managing Director was confirmed at our meeting yesterday afternoon. Your term of office will start on Monday, May 11th.

 I need hardly add that we shall be delighted to welcome you amongst us. We trust that your association with us will be a long and happy one.

 Yours sincerely,

 J.C.H. Twallin.
 Chairman.

Mr. W. R. Cass has been appointed managing director of BUCK AND HICKMAN.

This follows the retirement of **Mr. J. C. H. Twallin** and **Mr. T. R. Twallin** from their positions as joint managing directors. Mr. J. C. H. Twallin has been elected president of the company, and Mr. T. R. Twallin becomes vice president.

★

Cover of Buck and Hickman catalogue, 1971: "When I arrived at Buck and Hickman the main depot in Whitechapel housed 30,000 unsold tools and items, some dating back to the Boer War. We created a wonderful catalogue with hand drawings of all the stock – sadly, those illustrations are now lost."

What I didn't discover hidden in the nooks and crannies of the warehouse was money. We had practically none, and Warburgs was not prepared to lend us any more. I got my friend Peter Humphries, who was a brilliant auditor with his own accountancy company, to bring in 10 of his staff to chase debts both old and new, and within a few weeks we had significant money in the bank as well as debt-collection systems to keep these accounts growing. We also created a great catalogue for the first time, with wonderful hand-drawn pictures representing most of those 30,000 items.

In my first year there, the company turned its first half-million pound profit. It was exceptionally hard, stressful work, but I could see so much unrealised potential in the company and I was in it for the long haul. However, near the end of 1971, Warburgs came to tell me that a gentleman called Mr Jeffrey Stirling (now Lord Stirling) wanted to buy the company. He was mainly interested in Buck and Hickman's real estate, rather than the ironmongery or machine-tool business. I was sorry to see the business sold before I had finished with my plans for it, but such was my lot. Now my job was simply to get the best price possible. Knowing that Stirling had his eyes on the Whitechapel site in particular, I called in Richard (now Lord) Rogers, who was at that time still starting out as an architect, and he did an incredible design for the whole of

the site, which Laing Wootton assessed would make a potential profit of £7 million. This was the figure that we eventually got for Buck and Hickman Ltd. from the Stirling companies.

Having achieved such a favourable sale, I was owed a bonus from the major shareholders, Ionian Bank and the Twallin brothers. We had agreed they would pay 50% of the fee each. To my surprise, the cheque from Michael Behrens at the Ionian Bank arrived the day after the deal was done – but the Twallins paid me nothing! Warburgs thought I should sue, but I decided that going into battle with the Freemasons was not my game.

CHAPTER 8: ADVENTURES IN ART AND RETAIL

My Love of Colour

Getting the call about a struggling company; rolling my sleeves up and making the sometimes tough decisions; putting new systems and talented people in place, then watching the numbers rally as the company starts to turn a profit again: I loved the management game.

And in the early 1970s, I was at the top of that game. The family was settled in Highgate, and work was pouring in as fast as I could take it. But as much as I enjoyed going in to companies and taking charge, I hated having to leave before I was finished.

The Buck and Hickman job was a great frustration: I could clearly see the right future for the company, but the owners didn't agree. They thanked me, paid me off (well, at least 50 per cent) and sold the company out from under me. My Highgate neighbour Malcolm Horsman shook his head at me, and not for the first time. He was a company turnaround specialist too, but he had already made millions. He always used to say that I was not going about things the right way in my business career. "A fellow like you," he would tell me, "must own the front row of the stalls."

Sitting quietly in Highgate one Saturday afternoon in 1971, I had a call from a City friend of mine saying that the Reeves artists' paint company was about to be sold and that a friend of his named

Reeves Dryad Ltd. promotional materials, press cuttings. "It was when I joined the Reeves company, with its Enfield factory filled with vats of paint and boxes of pigment, that I truly discovered my love of colour."

REEVES COLOUR

Design Council Awards 1975

This card admits you to the presentation of the Design Council Awards by HRH The Prince Philip Duke of Edinburgh KG KT at The British Aircraft Corporation, Filton, Bristol on Wednesday 28 May

This card will also serve as a ticket for the special train boarding at Paddington from 08.00 hours and departing at 08.23 hours on Wednesday 28 May and for the return train leaving Bristol at 18.55 hours arriving Paddington at 20.47 hours on 28 May

United Kingdom

Please bring this card with you

Presentation of Design Council Award Certificate to Reeves Dryad

Design Council Award 1975

Consumer and Contract Goods

This certificate is presented to **Reeves and Sons Limited** to mark the selection of **A range of craft and colour kits: Fabric Printing Kit, Candlemaking Tub, Colour in the Round, Busy Board Rainy Day Colour Kit** Designed by Larkin, Stratton & May

On 28 May at a ceremony in Bristol, The Duke of Edinburgh presented the Certificate of the Design Council Award to Mr W R Cass, Chairman of Reeves Division. The products for which Reeves received the awards were: Fabric Printing Kit; Colour in the Round; Rainy Day Colouring Kit; the Busy Board and the Candle Making Tub. Above is a reproduction of the Design Award Certificate the original of which is signed by Viscount Caldecote as Chairman and Sir Paul Reilly as Director.

Left, Mr Cass accepting the certificate from The Duke of Edinburgh. In the centre is Viscount Caldecote, Chairman of the Design Council.

Reckitt & Colman's bid for Reeves Dryad

BY NICHOLAS LESLIE

RECKITT & COLMAN, the £150m. international foods and domestic products group, is moving into an entirely new product field with a bid, worth nearly £4m., for Reeves Dryad, the art and craft materials, educational toys and learning systems manufacturer.

The offer, which prompted a 28p jump to 86p in Reeves share price, looks likely to succeed since it is recommended by the Reeves directors and, with Takeover Panel consent, holders of 38 per cent. of the equity have already irrevocably undertaken to accept.

A factor behind Reckitt's decision is that its studies spotlighted the increasing amount of leisure time and money spent on it.

In 1971, Reeves was involved with a complicated takeover bid from Heenan Beddow. This was at first recommended by the Board, but the directors later changed their minds and rejected the terms, a move which prompted their advisers, Hill Samuel, to resign.

Mr. Christopher Simmons, a member of t he family which built up Reeves and then acting managing director, led the rejection move and he brought in Mr. Wilfred Cass, who is now chairman.

Terms of the offer are one Reckitt share, yesterday unchanged at 248p, plus 320p cash for every six Reeves shares—worth nearly 95p a share. Also, offers of 40p cash will be made

for each Reeves 3½ per cent. Preference share and 47p cash for each 4.2 per cent. Preference

A condition of the offer is that there is no probe by the Monopolies Commission—a move which is unlikely.

Accepting Ordinary shareholders will retain Reeves' second interim dividend of 0.575p a share for 1973 with Preference shareholders retaining dividends paid on May 1 and payable on July 1.

Reeves directors have been advised by St. Mary Axe Finance and Reckitt by S. G. Warburg, who will send out offer documents as soon as possible.

NEW IDEAS IN LEARNING... SKILLS TO ACQUIRE... CONCEPTS TO GRASP...

...Through a consistent, meaningful and complete programme, carefully graded according to ability and development.

"Reeves" is, and has been for many years, a household word; it stands for artists' materials of the highest quality – your first paint box at home or at school was probably one of ours.

Now, as a logical development in a Company that is so closely and successfully linked with education in several countries, we are proud to announce a new venture that will give the teacher and play-group leader an entirely new range of educational equipment and material for use with the very young.

Detailed and consistent research into the process of learning has been conducted in

Sweden by a team of teachers, playgroup leaders, psychologists and doctors. The work was initiated and financed by Esselte Studium of Stockholm, Northern Europe's largest educational company engaged in designing, manufacturing and marketing an incredibly wide range of educational aids to meet the needs of teacher and pupil from the nursery to the university.

The result of the research is a complete programme of learning for the young child at home, in the nursery or infant school, or in the play-group. Every item illustrated and described in this catalogue will ensure that you, the customer, may be confident of wise, far-sighted buying in an area where money has always been much scarcer than the vast range of poorly constructed and easily broken play materials.

I commend to you with complete confidence our new range for the very young.

Wilfred R. Cass
Chief Executive

Reeves promotional materials, 1972-1973: "Once again, I called on my friends from Wolff Olins to help bring the brand to life and extend its appeal."

Christopher Simmonds, who was a Reeves family member, was desperate to find somebody to intervene and stop the sale. I said that although I did have some previous experience with family paint companies, this time it sounded as if it was all too late. Eventually he persuaded me to at least take a look – the situation being so urgent that it had to happen that very afternoon. So it was that I found myself walking around a factory in Enfield with Christopher Simmonds, mouth open in total amazement.

Everywhere I looked was colour, wonderful colour. Great vats of paint and boxes of pigments were dotted across the factory floor in a riot of vivid hues: from Zinc White to Vermillion, from Rose Madder to Prussian Blue. The sense of excitement was almost overwhelming. The more I saw, the more it seemed crazy that this wonderful rainbow-manufacturer should be going to the wall. I saw no account figures, and Christopher admitted to me that the business was in fairly bad shape, but I could not get away from the living history of the Reeves brand, set out before me in all its technicolour glory.

We sat down on a carton and Christopher explained the situation. He and his immediate family owned a company that held 25 per cent of the listed stock in Reeves. The family had not given their

REEVES
FOR CHILDREN

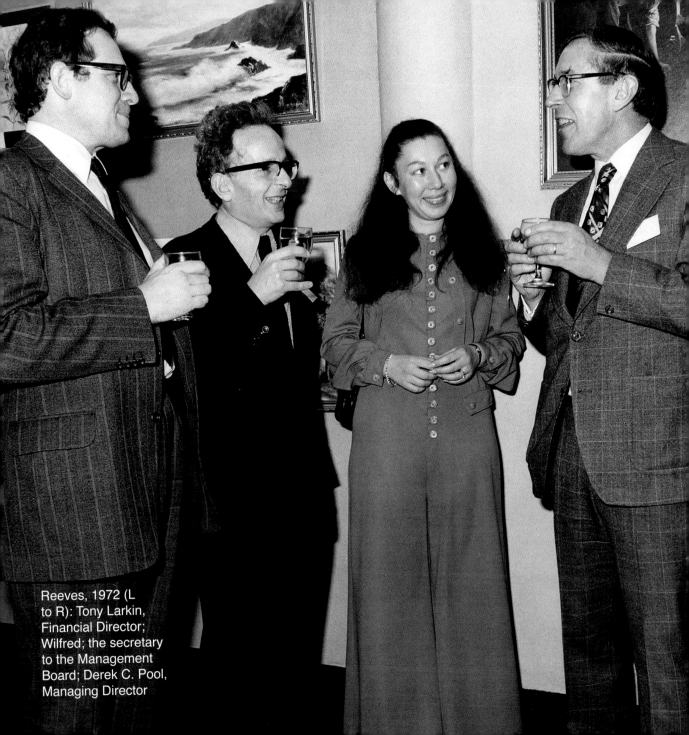

Reeves, 1972 (L to R): Tony Larkin, Financial Director; Wilfred; the secretary to the Management Board; Derek C. Pool, Managing Director

approval to the potential purchaser – an outfit called Heenan Beddow, which specialised in buying up ailing corporations and stripping these companies' assets for profit. Christopher offered to sell me a majority interest in the family shares, at a substantial discount to the market price, if I took on the task of fending off the predators and trying to rescue Reeves.

The paint firm had very large debts and I guessed that I would need at least £1 million to resurrect it. I could only dream of money like that. But the Cassirers have always been fast decision makers. Within ten minutes of walking into that factory, I had determined that Reeves had to be saved, and that I would do my utmost to save it. I just needed to find £1 million – by Monday!

The only person I could think of who might lend it to me was my neighbour, Malcolm Horsman, who at that time was running the giant paper company Bowater as well as his own company. I rang him up and said that this was his chance to help me buy that front row of the stalls he was always telling me about. Being a quick guy, he simply said "There will be a cheque for you in the post tomorrow." He was as good as his word. It was the first and last time in my business career that I borrowed a lot of

money – I don't believe in it, as a rule. But if ever a rule needed to be broken, it was then. I couldn't stop the takeover without owning those shares, and my gut told me that the brand alone was worth millions.

Next, I went to one of the big corporate legal advisers – Ashurst, Morrison, Crisp. I met with one of the partners, Martin Bell, and his young assistant Geoffrey Pickerill – a bright young chap who ended up acting for me in various legal matters for the next 30 years and more. To my surprise, they were prepared to take on this Mr Cass they had never heard of. I realised that a million-pound cheque is a key that unlocks almost any door. The lawyers and I had lots and lots of fun sending daily letters to all the Reeves shareholders, advising them to reject the takeover bid because we would do a much better job for them, and countering all their best arguments. Our opponents at Heenan Beddow were not best pleased. They countered with a letter to shareholders which began, "What do you know about Mr Cass?", implying that I was simply a chancer with no track record or relevant experience. True, I was not exactly a household name, and this was the first time I had hit the headlines to such an extent. But all my successes – Rotawinder, Gunson Sortex,

REEVES CRAFTS

Reeves promotional materials, 1972-1973: "At Reeves, I oversaw the purchase of the craft business Dryad Ltd., making the company into a total arts-and-crafts package."

MEN AND MATTERS

Here comes Mr. Cass

"What do you know about Mr. Cass?" starts a paragraph of what is politely known as a strongly worded letter from Samuel Montagu, on behalf of Heenan Beddow, to shareholders of Reeves and Sons. Heenan Beddow, once a small engineering business and now progressing swiftly (it sent its offers for Conway Stewart and for Reeves in the same document) from one takeover to the next under the command of Mr. David Innes, can be excused some testiness when it issues statements about Reeves. The anomaly in the position of the Reeves Board is that while it began by consulting Hill Samuel and accepting the bid, it has since decided that it won't do so with its own shares.

The Mr. Cass about whom Heenan Beddow complain that shareholders have been given no information of his experience or ability, is Mr. Wilfred Cass. He reckons, a little angrily, that City memories must be short if no one can place him. Was it not only in June that as managing director of Buck and Hickman, Cass sold that company to Sterling Guarantee for 550p a share, a notably successful sale since when Cass became managing director in May, 1970, the share price was in the 150p-175p range?

That was the last move in a career which has taken Cass gradually from electronics, starting with printed circuits at Pye of Cambridge in the 1950s, to a full management role. Apart from consultancy, he was a founder of the coil-winding company Rotawinder, was six years general manager of Gunson Sortex and had a spell in paint as boss of Hadfields.

Cass first came to Reeves at the invitation of Mr. Christopher Simmons, now the acting m.d. of Reeves, a member of the family who built Reeves, established in 1766, to its dominance of the educational art market. Through a private company, Cass was sold shares in Reeves at what amounts to about half the offer price. Cass says these were offered to him as "an incentive" to come in and (provided the bid is fought off) take charge of the company's ailing fortunes and that "I've been buying in the market as well."

So Mr. Cass's identity is firmly established. But there should be plenty of fireworks left in the battle, with Innes confident he will have enough acceptances to make it worthwhile carrying on the war after his first bid falls due to-morrow.

Absent

It is not only the unusually large posse of plain clothes men padding about outside Mr. Wilson's first floor suite at the Grand Hotel which creates a security conscious atmosphere at the Labour Party conference. There is also the absence of a familiar face, that of Mr. Igor Klimov, the Russian labour attaché. Klimov has been a regular on such occasions and at the TUC in Blackpool last month he was his normal cheerful self. In fact, he was nearly co-opted for the journalists team for its annual cricket match with the TUC General Council. Enough journalists turned up in the end, but Klimov stayed to watch.

When the spy fracas first broke, Klimov was spotted returning to the Russian Embassy and asked if he was on the expulsion list. He said he doubted if anyone would consider him a spy. After all, he joked, he was just returning from a meeting with Mr. Vic Feather.

But since then he has been confidently reported to be one of the 105. In Brighton, conflicting theories for his absence include that he had anyway been going on a holiday to Russia, or that he is enjoying a spell in the country, in Kent.

Back to basics

The plans of Prof. Edward Stamp to research some of the fundamentals of accountancy are progressing fast. Back in May, Stamp was appointed to the new chair of Accounting Theory at Lancaster University and at the same time plans for an international centre for research in accounting, with Stamp as director, were first aired. The centre has now got the money to start—an annual £10,000 donation for the next ten years from the J. Arthur Rank Group Charity. It will shortly advertise for a Senior Research Officer and then work (Stamp thinks it will probably take three years) will start on two principal research projects. One is to investigate (going right back to Square One) "the nature, purposes and objectives of published financial accounts." The other is to study the effect of inflation on the usefulness of accounts.

Stamp has been preoccupied with both questions for some time. A likeable Canadian, Stamp began his campaign for a reform of accounting practice just before the Leasco-Pergamon affair provided ammunition for his views. In the debate which followed, Stamp was none too popular with some members of the Institute of Chartered Accountants in England and Wales, among them, at times, its then president Sir Ronald Leach. But since then the English Institute has started on its massive investigation of accounting standards and Leach and Stamp are now in harness. It is Leach who as chairman of the Lancaster centre's Board has recruited some heavyweight City and industrial names among the other trustees to ensure, as Stamp puts it, that the academic centre "keeps at least one foot in the real world."

Outbid

I regret to report that the Financial Times VIII, of whom the largest member was the giant Michael Donne, who writes above, and the smallest the cox Dick Parsons we borrowed from Emanuel School (several lady members of staff having declined the honour) was defeated by the Stock Exchange in the first-ever contest between us over a half - mile course at Putney on Saturday. Excuses ranged from an over-long practice row to hitting more driftwood than the opponents, but the SE certainly had style on its side —two internationals and two old Blues, including Mr. David Parry of Panmure, Gordon, chairman of the Amateur Rowing Association selection committee. The umpire, captain of the London Rowing Club Mr. Philip Carpmael, reported that both scratch crews "set off at a young trained crew's rate and held it to the end. The FT fought off an attempt by the SE to take the best tide and were coming back at the end to lose by just a length." Which was very gallant of him, and since we lost by less than Lloyd's usually do and some of the jobbers looked a bit green by the end, we'll train on for next year.

Observer

An article from the
Financial Times, 1971
which later inspired the
title of this book

Buck and Hickman – had been excellent preparation for the Reeves job, as I told the journalist who interviewed me for the *Financial Times*. His article appeared under the headline, "Here Comes Mr. Cass".

As far as the City was concerned, I had made my grand entrance. The rest is history. We got a majority of the Reeves shareholders onside, and I walked in as the new managing director. Reeves had already lost most of its key senior staff, so I was able to build an amazing new team of very able works managers, finance managers and development people. The team soon began to work like absolute clockwork, and with things running smoothly at HQ, I was able to set about developing new products and diversifying the business.

At that time Reeves was really just a school paint supplier, but a new possibility began to crystallise: rather than simply providing schools with paints, perhaps Reeves could offer a broad range of educational and leisure art and craft supplies? I bought the Leicester-based craft business Dryad Ltd., and put the two companies together to make a much more balanced business.

The next step was to refresh the Reeves product range, and for that I turned once again to my old friends from Wolff Olins. Tim May and a few other key Wolff Olins people who had shone on

Reeves promotional materials, 1972-1973: "If these colours had inspired me to buy the whole company, surely the same thing might sell some colour and craft kits!"

the Hadfields brand identity had left to set up their own agency in Camden Town, and they jumped at the chance to work on the iconic Reeves brand. In a six-month period they developed some 50 children's products, from face paints to watercolour sets and all sorts of craft kits. All of these arrived in appealing, colourful boxes that cried out to be opened and explored: if these colours had inspired me to buy the whole company, surely the same thing might sell some colour and craft kits!

That colour scheme certainly did the trick. When we launched the new range at the next art product fair, it went down a storm and won the Design Council's special award, which was presented to us by the Duke of Edinburgh.

Matters of the Art

Something in the Cassirer DNA had drawn me to those stacks of colours, and not just the family's nose for a profit. I'm certain there's a little bit of artist's pigment in our blood. The impulse that pushed me to break my own rule against borrowing and take control of Reeves was an echo of the same voice that told Julius Cassirer to buy Pissarro; that told Paul Cassirer to buy van Gogh and Cézanne. It was during my time with Reeves that I became more closely entwined with the contemporary British art

world – the world that would eventually become the next phase of my life's work.

As well as children's products, Reeves supplied professional artists' products of all kinds. One day at the office, a man named David Michison rang through: He wondered whether certain of our paints could be thinned and adapted to achieve particular effects in painting. This wasn't for himself, however, but for his boss – the painter, sculptor, and all-round artistic genius Henry Moore.

Of course I knew of Moore – I even owned a piece of his, the "Mother and Child" maquette I'd bought at auction in Johannesburg a few years earlier. I offered some advice, and soon struck up an acquaintance with the artist, who was a very approachable man. I used to go down to see Moore once or twice a year after that and usually bought (or, occasionally, received as a gift) a drawing for my own collection, or sometimes a maquette. One thing puzzled me: I could never see that Moore was actually doing any sculpting! He was a Yorkshireman of the talkative persuasion, and we'd sit and chat for hours. Moore was constantly experimenting with ink and paint, so we had a lively ongoing discussion about special orders and the properties of the products that Reeves made up

for him. I felt very lucky to have this insight into the artist's process, and to play a small part in the prints he was making at that time.

Almost by accident, by following up on chance meetings and buying on instinct the things that I loved, I was starting to develop a small but respectable collection of British art – sculpture, paintings and drawings. As well as the Henry Moores I bought works by David Hockney, R. B. Kitaj and Elisabeth Frink, and I collected drawings and prints on my travels to Japan. Most of the important pieces I have now given away to my children, grandchildren and to Jean, but they brought a great deal of pleasure to me over the years.

Meanwhile, the Reeves success story continued. After four years under my management, the company attracted a takeover bid from the venerable household goods company Reckitt & Colman, which was looking to diversify into the leisure industry. This time, the Reeves board recommended that the shareholders accept the offer, and in 1976 I acquired a new set of bosses. I was given the job of chairman of the leisure division, which meant having to make regular presentations to the Reckitt & Colman board. They were all very charming, but you can imagine how much I hated it! Working for other people is just not my style at all.

I advised the leisure board of Reckitt & Colman to add another art supplier, Winsor & Newton, to the portfolio. Like Reeves, Winsor & Newton had been supplying paints and art supplies for generations. It turned out to be a rather better company than Reeves, and all my key people deserted me to run Winsor & Newton. Sadly Reeves suffered, and my motivation for working with Reckitt & Colman dwindled still further. Their mania for the leisure market was misguided, since the leisure penny went to games, electronics, football – anything but arts and crafts toys. It was time to move on.

Family Business

When Reckitt & Colman Ltd. bought Reeves, I opted to buy two of the Reeves Art shops which they had lost interest in. I also took a lease on a third shop, in Knightsbridge underground station. My daughter Nikki had just left school, and I put her in charge of the station shop, which was the smallest of the three. She made it a very exciting gift shop, doing all the buying herself and running it with no staff. From day one, she had the most amazing sense of colour – an instinct that has since blossomed as Nikki has developed her career as a glass artist, designer and teacher.

I took over the shop in Knightsbridge Green, which I renamed Cass Picture Shop and tried to run as an art gallery with my wife

Marino Marini

Exhibition of Graphic
works 1950-1976

Main exhibition at: 11, Knightsbridge Green, London SW1 · Tel. 01-5898038
Extra exhibition at: 13, Charing Cross Road, London WC2 · Tel. 01-9309940

15 - 27 nov. 76

Catalogue from
Wilfred's exhibition of
Marino Marini at the
Knightsbridge Green
Cass Picture Shop

Jean. I had the best of intentions, but sadly she was not terribly interested. The gallery opened with a good show of Henry Moore prints from Henry and the Curwen Lithograph Studio. Next, I managed to persuade Marino Marini to show a full set of his graphics in England for the first time, and to make a new portfolio. I was proud of the deal but we had far too short a time to prepare the exhibition, and no marketing to speak of. The images, amazing as they were, met with a lukewarm reception. It came right for us many years later though, when the prints were sold at Sothebys to fund our new Bulthaup kitchen! As much as I love art, I am rarely sentimental when the time comes for a piece to be sold.

The third shop was in Charing Cross, and that one went to my son Mark. He hit the ground running, learning retailing and accountancy on the job. On his third day he discovered a major fraud that had been damaging the profits for years, and called in his sister to do the undercover work, collecting the evidence he needed to stop the culprits. Not content with running an art supply shop, Mark soon negotiated a franchise deal with a camera dealer called Photomarkets. He remodelled the front of the 800 sq. ft. store to sell top of the range cameras, and learnt how to bargain and sell. It was a brilliant success, and I'm sure the skills he acquired there laid the foundations for his subsequent career in retail.

Marino Marini,
"Arlecchino", 1974

Nikki running Cass Arts & Crafts shop in Knightsbridge underground, 1976; with her glass art, today: "Nikki is the Cassirer's artistic side. As a child, she loved the perks of my work at Reeves – the paint sets, the colours – and that love continues today, with her own successful glass sculptures and architectural glass business."

Mark and Nikki are both Cassirers through and through, even if they represent different sides of the family traits. Mark is just like me, an ambitious and decisive businessman. In fact, the working relationship he and I have developed is quite exceptional – we each know what the other will say and do in a way that makes it great to work with him and, I believe, makes us a formidable team.

Nikki, on the other hand, is the Cassirer's artistic side. As a child, she loved the perks of my work at Reeves – the paint sets, the colours. And it's a passion that stays with her today, as she continues her own artistic practice making vibrantly colourful architectural glasswork. She's also maintained the Cassirer tradition of pushing boundaries in both her artwork and her work as an educator, using art to teach children who haven't had as many opportunities as she did. Instead of following the Cassirer passion for business, Nikki has chosen a life driven more by nurturing and creating, like our artist and philosopher forebears.

I suppose I did put some pressure on them at a young age, but both Mark and Nikki really rose to the occasion. I believe that bright young people at 18 or 19 have all the skills they need to succeed professionally, they just have to be spurred on to take responsibility. The potential is all there already – although I must say that experience helps you to get things done faster.

Cass Arts newsletters and Cass Electronics notices (this page and next), circa. early 1980s: "Cass Arts & Crafts and Cass Electronics – operated by my brother Eric – both exploded as businesses in the early 1980s."

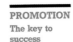

PROMOTION
The key to success

CASS **ARTS & CRAFTS NEWS** FREE

Christmas Greetings and Gifts for all the Family

A few of our Christmas decorations and gifts to set the mood for an idea-packed issue of guidance, new products and 'Best Buy's' to help you choose the right gift for your family and friends.

★ GIFTS GALORE ★
CHRISTMAS ISSUE
1981
8 pages of Gifts & Toys
Rug Making Feature
'60-second' Picture Frames
– BIGGEST RANGE ANYWHERE? –
Artists' Paints & Materials
– CUT PRICE OFFERS –
New Materials & Patterns
FOR THE DRESSMAKER

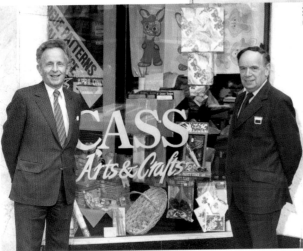

CASS *Craftsmith* · DESIGNERS EYE · FREE
Arts and Crafts News

NEW 'MAKE YOUR OWN CLOCK' KIT

Our new Clockmaking Kit is assembled in five minutes and provides everything EXCEPT dictating the colour and design of the clock back- ... regularly looked-at, so why ... attractive to you — and is all

AUTUMN 1981
CONTENTS
Sirdar Wools Check List

Latest Craf...

Art Materials - ...

Colourful Tapest...

New Cascade Dr...

New Autumn Fab...

ALL KINDS OF 'CREATI...
IDEAS & 'VALUE-FOR-M...

Time Out
CHEAPEST IN TOWN

There's no real reason why DIY picture- framing should be as expensive as it is or why the £2-worth of glass, hardboard and frameclips I bought the other week should have cost me a ridiculous £10.99 just be- cause it had been put together in a flash Instaframe box. As is the way of these things, it was only after I'd paid up that I came across **Cass Art**... the Charing Cross Roa... display announcing t... cheapest frames in L... £1.45 for the 5" by 5" v... to £11.95 for the poster- size. Their pine and alu... even better value in c... prices charged in less... stores: the biggest pine... comes with backing and... silver or gold aluminiu... clude backing, glass an... start at £3.60 for the ve... up to £12.50 for the 20... Cass Arts and Graphics... Rd, WC2 (930 9940)... tube. Open 9.15am-... 10am-5.30pm Sat. (Joh...

New! **Instant Framing** from *Cass Arts and Crafts*

Custom Framing

SPECIAL PRICE
Reduced from £3...
£1.75

£9.99

READY MADE
ALUMINIUM PICTURE
FRAMES GLAZED
16in x 20in

Instaframe®
SPECIAL PRICE
£4.75

Fine Art

FREE

CASS Arts & Crafts

"Cass Arts changed form several times and was begun anew by my son Mark – it still flourishes today – while Cass Electronics was also extremely successful, eventually being bought out by my old employers, Telephone Rentals."

CASS ARTS DIRECT MARKETING 1982
AND LOCATION OF RETAIL OUTLETS

RICHMOND
18 George Street,
Richmond, Surrey TW9 1JG
Tel: 01-940 9987

SLOUGH
170 High Street, Slough,
Buckinghamshire SL1 1JN
Tel: 0753 29318

CENTRAL LONDON
13 Charing Cross Road,
London WC2
Tel: 01-300 9940

WEST LONDON
11 Knightsbridge Green,
London SW1
Tel: 01-589 8838

HEMEL HEMPSTEAD
216-218 The Marlowes, Hemel Hempstead,
Hertfordshire HP1 1BH Tel: 0442 51302

CONGRATULATIONS
Date: 22nd April 1982
BISGOOD, BISHOP & CO. LTD.
COPTHALL HOUSE,
48 COPTHALL AVENUE
LONDON EC2R 7DN.

TR pays £8m for Cass

BY FRANK KANE

Telephone Rentals, the communications group which claims to be second only to British Telecom in apparatus supply and service, yesterday announced an agreed offer for **Cass Group**, valuing the company at £7.9m.

Cass announced on August 6 that it was in negotiations with several unspecified other companies which could lead to an offer, and this pushed the group's shares as high as 205p at one stage. However, TR's all-share offer—three of its own ordinary 25p shares for every four of Cass's 10p ordinary—values Cass at 135p per share, exactly the opening price on August 6.

It is understood that other potential bidders were put off by the possibility of difficulties in the Mitel PABX marketing operation, which has incurred sizeable start-up costs. In the

the shares and who have recommended the offer, said last night that he was "very comfortable" about the terms, and rejected suggestions that TR would acquire control at a knockdown price. He said, however, thata there would not have been a deal if the large Cass shareholding was not pledged for it.

Mr Eric Cass, the chairman and chief executive who holds some 3.39m shares, or 58 per cent of the total, is to resign along with his brother on completion of the deal. This is in line with his stated intention to reduce his commitment to the company and provide for strong management succession.

TR said that the telecommunications activities of itself and Cass were entirely complementary, and the acquisition would provide it with an entry

... market, ...ncy signal- ... residential ... housing, ... will be of

"stra
the r
Bo
yeste
for t
saw
from
perio
dowr
comp
all
divis
trad
quot
and
At
to £
turne
Mr
direc
disa
prim
sidi
Repu
seas
cent
Th
raise
earn
and
reco

146

Cass Electronics ready for USM introduction

BY TERRY GARRETT

PRICING new issues is not the easiest of tasks at the best of time: get it too wrong and there are questions in the House. Brokers Savory Milln are scratching their heads with just such a problem. Their issue, Cass Electronics, is nowhere near the Amersham league, no MP is going to get excited if Savory gives the company away, but it still presents a tricky pricing

cent of Reeves and Sons, manufacturer and distributor of artists materials. That company too was sold (five years later to Reckitt and Colman) but from there Wilfred set up his own art materials business with two retail outlets.

The two brothers have worked closely together over the years but the catalyst for bringing the two separate companies together was Arts' purchase of three Craftsmith shops from W. H. Smith for around £250,000 in February 1981. Electronics provided Arts with the money to finance the deal.

Electronics was one of the first companies to launch direct speech intercommunication from which it has expanded a wide range of system—programmable bleepers, hospital communications, alarm calls for sheltered housing (the elderly) and telephones (PAX) are just a few examples.

Close to 10 per cent of the equipment supplied is on a rental basis and a national service and maintenance operation backs-up cash sales and rental agreements. About one-third of it scustomer base is industrial and commercial clients with the rest accounted for by the health care market—local and central Government.

In the last three years sales by Electronics have risen from £1.9m to £3m (putting aside Faxdata, a company acquired in 1980 supplying a range of nurse call units). Trading profits have more than doubled from £329,000 in 1979 to £724,000 last year.

The acquisition of the Craftsmith shops has obviously transformed the Arts side. Trading profits jumped from £33,000 in 1980 to £185,900 last year on a

£1.2m advance in sales to £1.6m. Wilfred Cass is confident that he can produce decent returns where W. H. Smith failed. The shops he has purchased were trading profitably before Smith applied central overheads so Cass was not taking on loss making sites. Stock levels have been doubled and ranges expanded by adding four new departments including DIY picture framing (evidently a growth area) and "true" artist materials. More lines geared towards male customers and children have also been introduced.

From the retail base Arts is expanding into mail order, selling embroidery and stitching kits through the Sunday magazines.

Taking the company public, the Cass brothers believe, will give a boost to its image when dealing with industrial and trade customers—which include household names like ICI and BP— and local authority buying departments. From that point the USM launch is a marketing exercise.

But it also allows the family to raise cash out of the business both now, and perhaps in the future. Apart from the £0.5m of new money for the company Eric Cass will sell a 10 per cent holding, reducing his stake to 62 per cent. Other members of the Cass family, including Wilfred, will hold a total of 18 per cent.

Also, the move gives Cass paper to make acquisitions or launch further issues. The brothers see opportunities for both complementary businesses in Electronics and further stores for Arts. But they don't see themselves taking the company into another unrelated area

ITAGES OF CASS COMMUNICATION SYSTEMS

2 CASS will carry out the whole project from design to installation so the fullest co-operation can be guaranteed at all stages.

5 Design is standardised throughout the CASS range, so that the systems have a neat uniform appearance. A CASS system, in fact, looks like a system, not a collection of bits and pieces.

3 All communication requirements are dealt with by our organisation bram first consultation to arrangements for servicing.

6 Service and maintenance costs are low; in addition to an exchange unit replacement scheme, all CASS equipment can be covered by an annual "all-in" maintenance contract.

You would think that there would be a corresponding loss of physical energy as one grows older, but not if you're dealing with a Cassirer. There's a family anecdote about my great-great-uncle Max Cassirer, who owned several pulp and timber factories in Silesia (now Poland). His nephew Martin travelled with him to inspect one of the factories, and they stayed overnight in a small apartment that Max kept for this purpose. Martin was not an early bird, but he was very keen to do the right thing by his much older uncle, and see to the morning arrangements in the flat. Setting his alarm for 6.30am, he went to sleep and duly woke with the dawn, only to find a note from Uncle Max on his bedside table. It said, "Breakfast is on the table, the bathtub is ready – I'll be waiting for you at the factory."

A Most Convenient Meeting

Whether it's sitting next to a key Sharp executive on the plane to Japan, or sceptically walking into the Reeves factory only to be stunned by its possibilities, the course of my career has often been steered by strange and coincidental meetings. But perhaps none was as strange as the moment which catalysed my next venture: I met the managing director of WHSmith in the gentlemen's loo at the Savoy. He told me that he was considering selling his WHSmith Arts and Crafts business, which had opened about

four years earlier when I was running Reeves. These miraculous shops were making gigantic losses due, it seemed clear to me, to mismanagement by an overstaffed head office comprised of totally new people. It was a major missed opportunity, and I wanted a shot at it. I just needed to find some financial backing.

Perhaps it's the Cassirer in me, but 'business' and 'family' always seemed to go hand in hand. It was a natural next move to approach my elder brother Eric, who was still running Cass Electronics. He agreed to buy Cass Arts, the company I had started with the former Reeves shops, and pay for the initial running costs of WHSmith Arts & Crafts. The deal with WHSmith was simple: we paid nothing for the business except for taking over the leases. Mark, Nikki and I constituted the whole head office of the new business. We spent most weekends changing stock and moving fixtures, to the consternation of the staff when they returned to work on Monday mornings! Nikki and I went on long buying trips in the Far East, stocking up on Christmas merchandise. We then also bought a chain of graphic shops, which with the benefit of hindsight was not the greatest idea, as the increased workload stretched us all beyond any sensible limits.

WH Smith ready to push Paperchase into America

Cass Arts & Crafts nearly merged with Paperchase, but WHSmith beat them to the punch

Trying to make sense of this varied business, and with very little management to rely on, I looked for more established larger organisations that we could take over. I got to know John Bray who had started the stationery and crafts shop Paperchase, and we got very close to agreeing a deal which would have seen us rebranding all our shops to the Paperchase format. A day before our final meeting, John rang me to say he had sold the company to WHSmith! I had a similar experience with trying to take over Rymans the stationers. Unfortunately my erstwhile benefactor from the Savoy loos, who had sold me the company in the first place, was now buying up all the sorts of concern I needed to strengthen my own retail chain.

After the initial three-year period, the original Craftsmiths leases we had taken over started to double, and in some cases even treble. The Cass Arts & Crafts business found it very difficult to survive the rent increases, and we eventually closed the large stores with great final sales. More recently I have watched the Hobbycraft stores revive the concept behind WHSmith Arts & Crafts, with great success. That proves to me that it was a good idea, but fell victim to the economic climate of the time.

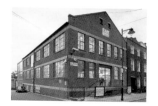

Mark's flagship Cass Art shop, in Islington, London

We eventually sold the three original Reeves art shops as well. By then, Nikki had moved to Wales and started her glass arts studio. But in the Cassirer tradition, one of those shops – the Charing Cross branch – stayed in the family. My son Mark bought it and started his own Cass Art business, which today has six thriving stores across London and is still growing.

CHAPTER 9: BIG BUSINESS

New Ideas, New Business Horizons

One of the smartest business decisions I ever made, without even knowing it, was buying our house on the Southwood House estate in Highgate. It was quite a gamble at the time – I had to get a mortgage for two thirds of the £6000 asking price. That felt like a fortune at the time, although the house is now worth more than a million! But living there put me in amongst a network of like-minded people. Alongside the art experts Klaus and Gretel Hinrichsen, the Adès family, and the actor Paul Rogers, I was also neighbours with the likes of publishing giant Bob (now Lord) Gavron and Malcolm Horsman. I picked up lots of informal business advice over the years, and more than one real commercial opportunity. The most significant of these arrived without much fanfare in 1979, and grew over the next 25 years to the extent that it funded the development of the Cass Sculpture Foundation.

By the late '70s I had bought the house next door as well, and Mark and Nikki were living in it. I was also using it as my office, running my consultancy business, working on Cass Electronics with Eric, and helping to run a charity there – the English branch of the Kennedy Foundation's Special Olympics International. Eunice Kennedy wanted to replicate the success they had had in the USA, working with people with intellectual disabilities involved in sport.

Bank Statement

- 2.5 million new images every year
- 450 of the world's leading photographers
- 537 of the world's most creative illustrators
- Free searches when you visit the world's largest contemporary visual resource

For FREE copies of our 1991 catalogues, phone us now on

071-240 9621
London

or

061-236 9226
Manchester

THE IMAGE BANK.

"THE WORLD'S ONLY COMPLETE VISUAL RESOURCE"

In 1979, Wilfred set up The Image Bank of London

She was a very inspiring woman and it was hard to say no, despite the fact that there was no funding and no programme. So I had a lot of plates spinning, and not very much space in which to spin them.

In 1979, our friend and neighbour Derek Kartun, another prominent and cultured businessman who lived in Southwood Lane with his wife Gwen, dropped by to ask if I could find him an investor in a new idea called The Image Bank. There was an outfit of that name in New York City which owned a large photo library of pictures by the world's best photographers. Derek proposed that he should run a London franchise of The Image Bank. He told me he had found a lady who was working in a similar operation in London and was in his words "very switched on".

The photo library concept was quite new to me, and it sounded amazing. Sadly, I did no research at all and only realised some time later how many excellent competitors there were in this business – first-rate companies such as Tony Stone Images. But at the time, I must admit that my main motivation was to get my hands on a desk and a telephone in central London, away from the kids and the clutter of the Highgate house. I regularly needed to go to Cass Electronics, Gunsons, Cass Arts Charing Cross and

some of my other consultancy clients and it seemed to me that this Image Bank idea could give me a free office. My son Mark agreed to be my partner in the venture – he had always been interested in photography, and at that time was running the Cass Arts store in Charing Cross Road.

Beginnings and Endings

But before I got my office, we would have to negotiate with the Americans. A Mr Kanney and his family ran the original Image Bank in the USA – tough, canny East Side New Yorkers, who employed an ex-taxi driver as their legal brain. They already had one agent in Europe, a charming Frenchman named Patrice who ran the franchise with his boyfriend. The Kanneys told us that they were doing great business in Europe and that we would have to pay £30,000 for the license fee and put a very impressive office into the centre of London, which might cost another £50,000. This was not on the cards for me. Derek eventually managed to negotiate not to pay the license fee as long as we put up a super-duper London office. So The Image Bank of London was born. I got my desk, and my phone, but the business was very, very slow and losing lots of money. Unfortunately Derek had to go, along with the young lady he had recruited from the competition, who didn't turn out to be all he had promised. The few sales we had seemed not to produce any cash. I began to wonder if I had bought a lemon.

The world's
leading agencies
go to the Bank.

3,000,000 STOCK answers for your advertising campaign.

THE IMAGE BANK

Wilfred ran Image Bank
with his son Mark

Back at home, things were in trouble too. Jean and I had been leading increasingly separate lives for the last decade. I was a workaholic from the word go, and having a family didn't change that: my career had always taken precedence over my marriage. For most of my time with Jean I was leaving on a plane every week. Two people who were not terribly compatible to begin with had become virtual strangers to one another. We divorced in 1981, after almost 25 years together. Jean got the house in Highgate and our holiday home in Corsica while I moved into a small bachelor flat in New Compton Street.

I threw myself into my work, determined to get The Image Bank out of the blocks after a sluggish start. In 1982 we took on an American lady called Jill Satin, who was a wonderful addition and really got the business going. She was an astute saleswoman, but was also kind-hearted, and she felt very sorry for her unattached boss. She told her friend Celia about me, and Celia mentioned that her mother-in-law Jeannette was also alone, having been widowed quite recently. I was very keen to meet this reportedly beautiful, cultured lady, but she turned down an invitation to a party at my house. She did, however, offer a consolation prize in the form of a cup of coffee at her flat.

Image Bank was the first of Wilfred's ventures to include Jeannette, who would become his wife and partner

I arrived at Jeannette's flat at 7 p.m., left after midnight – and that was it: for what was really the first time in my life, at the age of 56, I fell 100 per cent in love. It's a very strange feeling, getting hit by something new that you never thought would happen. Jeannette was and is an amazing lady, of a type that hardly exists today. She faced police surveillance and harassment when she spoke out against apartheid in her native South Africa as a student, had four children by the time she was 25, and went on to work as a fashion buyer and designer in New York and London to support her family. Today Jeannette has 24 great-grandchildren. Since almost the day we met, she has been my right-hand woman in all areas of my life, not least of which is the Cass Sculpture Foundation. But that's another story, which I'll get to in a little while.

One of the first jobs I roped Jeannette into was chasing the debts that were owed to Image Bank. She was charming but ruthless, and did an incredibly good job. Jeannette understands business, and I could talk to her about my work. It was a new experience for me to have this meeting of minds with a woman I loved, and I was happier than I had been in years. Not everyone was thrilled by my union with Jeannette, however. We travelled together to a franchise meeting in New York, quite early on in our relationship, and she introduced me to her late husband's nephew. He was most disapproving, and gave the distinct impression that he

thought I was a gold-digger, chasing Jeannette for her fortune. I thanked him profusely for telling me that my new partner had lots of money, as I hadn't known before, but that would make the future much easier for me! He nearly had a heart attack, and in all the years that followed, he never really came round to my sense of humour.

Getting the Business into Gear

As it turned out, at least for the time being, Jeannette's money was safe from me! Under Jill Satin's management, The Image Bank of London was really starting to take off. We moved to larger offices and grew more confident in our strategy for running the business. At the same time, we grew proportionately more fed up with the Kanneys' management approach. In 1986 we called a meeting of Image Bank International at our home near Marbella. Mark and I took the opportunity to propose to the Kanneys that they should put us on their board in New York and give us a 10 per cent share of the business. This was accepted in principle, subject to approval at a board meeting in New York.

When Mark and I attended the board meeting in New York, one of our strategic suggestions was that perhaps more funds should be used on the business, and less on the Kanneys. All the Kanneys replied, with one voice, that the whole fun of running the business was "to piss away the money we are making". Mark and I went out

Image Bank promotional materials, 1980s: "The Image Bank of London turned out to be one of the most important projects of my career – not only because of the financing it provided, but because of the links it gave me to the art world and because I ran it with my son, Mark. And yet at first, my priority in starting the business was mainly just to get a central London office!"

The Image Bank Guide To Filmmaking.

ABOVE · THE · LINE

THE IMAGE BANK
01-240 9621

Bank Managers

• 2.5 million new images every year
• 450 of the world's best photographers
For a copy of our FREE catalogue phone
01-240 9621

THE
IMAGE BANK
VIDEO DISC

THE IMAGE BANK.
IMAGE
"THE WORLD'S ONLY COMPLETE VISUAL RESOURCE"

Reproduced by kind permission of "The Guardian" — Thursday, May 12th, 1988

Cass . . . willing to install all the equipment

Updating the bank's image

New technology, it seems, has finally reached the archaic world of picture libraries. The Image Bank, probably the largest organisation of its kind with offices as far apart as Moscow and New York, has just introduced a video disc system which threatens to revolutionise the business.

Once the system is fully operational, art directors in agencies will be able to flick through thousands of transparencies in the comfort of their own offices, assuming, of course, that they have installed their own video disc system.

If they haven't, Wilfred Cass, the man running the London operation, assures us that they can be installed quite cheaply.

The Image Bank is the brainchild of an aggressive American businessman called Stanley Kanney.

Kanney set up the outfit ten years ago and now finds himself running a $10 million business.

THERE'S ONLY ONE AV COMPANY ON EARTH

THE IMAGE BANK
AUDIO VISUAL

Mike Gerrard on the success of a new way of handling pictures

Laser looking fast

Above: "The original Image Bank catalogues, centrally produced in the USA, didn't sell very well in the UK."

Opposite and overleaf: "Mervyn Kurlansky revolutionised the Image Bank catalogue design. He persuaded me – and Mark and Rex Jobe – that showcasing fewer, more dramatic images would sell more. He was right, and his new approach soon became Image Bank's international house style."

and had a chat in the gents (I've always found that a lot of the real business decisions happen in such places!). The gist of it was, "These people are crazy. Should we be doing business with them?" It was a deal that promised major financial rewards for us; on the other hand, we could see that we would never have any real influence on them. Anyway, we decided to take the risk, and duly signed the deal. Perhaps inevitably, the idea of us having oversight of the company budget made them go rigid. They took advantage of a get-out clause in the contract, and got out after a couple of months.

Money has never been the chief motivation in my life and career, not because I don't enjoy the things it can do, but because I've always found that I can get what I need when I need it. So for example, when I wanted to buy a house, I would work out a way to earn the money to buy it. But The Image Bank was different. This was the first business deal I had made with the potential to make serious money for me personally – money that would allow me to do something really interesting with the rest of my life. Although the 1986 deal didn't work out, I knew that The Image Bank was the big one. However badly the parent business was being run, it was worth sticking with it for the long haul.

LIFE
SPORT
NATURE
TRAVEL
WORK
IDEAS
THE
IMAGE
BANK

Mark and Wilfred celebrate 10 years of Image Bank

One of the Dallas franchisees, Rex Jobe, had become a great friend of ours, as had his wife. We bonded over our dislike of the Kanneys and the way they ran the business. In 1990, Rex managed to bring together some investors to buy the business and from then onwards we started to have much more fun!

In 1991, soon after Jeannette and I had moved to our current home at Goodwood, we hosted a board meeting with Rex's new management team that would be a turning point in The Image Bank's fortunes. They came with their Powerpoint presentation, full of sales projections and analysis. We came with plans for a wholesale revolution: a total revamp of the catalogues, pricing and everything else. Our friend Mervyn Kurlansky, one of the founders of Pentagram and acknowledged as one of the world's most influential graphic designers, worked with us to put forward a brilliant design presentation which Rex accepted. Mervyn went on to redesign not just The Image Bank's catalogues but also its logo and identity. More recently, his creative input has shaped the visual identity of the Cass Sculpture Foundation, and he's been a valued member of its Board of Trustees.

CHAPTER 10: CHAIRMAN OF THE BOARD

Reinventing a British Classic

Although I remained on the board of The Image Bank, I stepped back from the day-to-day running of the business after the first ten years – partly because Mark told me he thought it was time for me to do something else! Jeannette and I were starting to make plans for the next stage of our lives – we were house hunting in West Sussex, and beginning to put serious thought into a passion project for our "retirement". But in the meantime, I was still very busy with my other advisory roles, not least as chairman of Moss Bros.

I had known Monty Moss for many years. While I was running Image Bank in Charing Cross Road, he was a regular visitor, and always full of tales of woe about his company. At one stage, around 1984, things got so acute that Moss Bros. owed some £5 million to Lloyds, who were demanding action, and none of the options were particularly appealing to the Mosses. It took some persuasion, but Monty and his uncle (who was the Chairman at the time) finally prevailed on me to come in as Managing Director and Chairman, and to try and get this fine old company going again. With my friend Peter Humphries, who knew everybody who was anybody in the financial world, I went to see the bigwigs at Lloyds. Somehow, we persuaded them to give me a year to try to save the business. They even agreed to hold off on demanding any property or other assets as a guarantee – but now the

The new Regent Street
Moss Bros. shop
opened in 1989

pressure was really on, with a 12-month deadline to turn the company's fortunes around.

Michael Peat (now Sir Michael Peat) was Moss Bros.' auditor and, as luck would have it, he and I saw the firm's problems and what was needed to solve them in exactly the same way. We clicked immediately, and have been firm friends ever since. Michael is a truly great man who, very unusually for an accountant, does not just think like a bean counter. He has been a great influence on me, and I like to think our admiration is mutual. Together, we wrote an ambitious vision for the future of Moss Bros. Not for the first time, I found people queuing up to pour cold water on my plan. Michael Gee, a previous MD of our competitor Cecil Gee, described it as "straight out of Grimm's Fairy Tales".

Moss Bros. had been hiring and selling suits for more than a century, and it showed. By the mid 1980s it had fallen on hard times indeed. It made very little profit, and although it was still a famous brand, it was not being exploited and felt very out-of-date. At the time I came on board, they were considering some interesting business models, the main one being a concept called "Suit Company" that looked as though it had the potential to introduce a new, younger customer demographic to the brand.

I decided that we should roll that out and try to drag some of the Moss Bros. shops up to date. The company's main headquarters was our biggest headache: a sprawling warren of a building in Covent Garden that occupied half a city block and had so many entrances and exits that I don't think anyone knew how many employees worked there. Nobody at Moss Bros. wanted to admit it, but it was clear to me that the building had to go.

In 1988, we moved our business headquarters to low-cost Clapham and sold the Covent Garden site to a Japanese investment group for £23 million – £4 million more than our best expectation, and a great result. That same year, we bought rival menswear retailer Cecil Gee which, despite some problems of its own, was more up to date in its range and had some very good shops in key positions. What's more, the company came as a package with the founder Cecil Gee's three sons – including the sceptical Michael, who had accused me of telling fairy tales! As it turned out, the three Gee brothers were a breath of fresh air, and the kind of buyers and traders that the company really lacked. At first there were some delicate family politics to negotiate, as it was clear to me that one of the younger brothers was the most able manager. But I somehow managed to promote him to Managing Director of the Moss Bros. Group without any actual bloodshed.

Moss Bros. Covent
Garden, 1989 (L to R):
David Moss, Monty
Moss, Wilfred

Moss Bros. notices, late-1980s: "While dress suits were Moss Bros. bread and butter, it was real estate that rejuvenated the venerable brand. I negotiated the sale of the massive HQ building and the opening of its new flagship store – all while buying both Cecil Gee and Hackett."

Moss Bros advises caution

By Wolfgang Münchau

Moss Bros, the menswear shop, has issued a warning about its full-year results. Higher interest rates and their effect on consumer spending plus the sale of the Covent Garden shop, would make final-year results difficult to forecast, it said.

For the six months to July 30, the company achieved profits before tax and exceptional items of £685,000, up from £475,000. Turnover was up to £15.03 million from £11.91 million. There was an exceptional credit of £559,000 – the profit on the property sale.

Earnings per share, excluding exceptional items, were up at 3.46p from 2.43p. The interim dividend was raised to 1p from 0.58p.

The company said the benefits of the recent restructuring, which included the £12 million take... and t... Cove... begin... next... inclu...

Th... Hack... has ... ing d...

Warning note: Wilfred Cass, chairman of Moss Bros

Cass: Regards final price as a bonus

Moss Bros London shop sold for £23m

Moss Bros, the menswear group, has sold its shop in Covent Garden, London, to Kumagai Gumi, the UK arm of a Japanese construction group, for £23m.

Kumagai Gumi, which has been developing and investing in London property for two and a half years, has already paid 5% of the price. The balance is expected to be paid in cash next month. It plans to convert the site into a mixture of offices, retail and residential developments.

The sale is a major boost for Moss Bros, which announced in August that it intended to realise the value of its property asset. The store had been given a value of only £1.5m in the company's books.

Wilfred Cass, Moss Bros

chairman, who was ex... bids of about £19m, ... regarded the final pr... bonus. The Moss Bro... price jumped a su... 150p from a post-Cra... on news of the sale.

According to Ca... company had rece... number of approaches the building.

The sale of the s... enable the group to r... its modernisation p... me,' Cass said.

Proceeds of the s... also go some way... paying for new outlets Moss Bros will p... have a shop within t... development.

The sale is conditi... shareholders' approv... meeting next month.

Moss Bros seeks new dire...

The menswear group is considering moving into laundry and car hire, **Patrick Hosking** reports

Wilfred Cass is considering licensing brand names.

MOSS BROS, the menswear group famed for hire operations, is to look at ways of cashing in on its prestigious name and diversifying out of menswear retailing.

The 136-year-old quoted group, which will soon have a cash pile of almost £23m from the sale of its flagship Covent Garden building, is looking for a faster rate of expansion.

Car hire and other rentals, laundry services and the licensing of its brand names to manufacturers of suitcases and perfumes are among the ideas being considered by Moss Bros chairman Wilfred Cass.

He is about to hire an adviser from four shortlisted marketing consultancies to investigate the options. Merchant bank Samuel Montagu and stockbroker Warburg Securities are providing advice on the financial aspects.

An admirer of the strategy of Ralph Lauren and Dunhill, Mr Cass hopes to exploit his group's brand names, which include Savoy Taylors Guild, Beale & Inman and Moss Bros itself.

Savoy Taylors Guild and Beale & Inman were acquired when Moss Bros purchased Cecil Gee,

a rival menswear... agreed £12m tak...

Moss Bros, w... terim results r... plenty to spen... Last December... sale of its Coven... for £23m to the Japanese construction group Kumagai Gumi. The bulk of the payment will be made in February.

Moss Bros has already had a traumatic year, absorbing Cecil Gee and launching specialist Suit Co and Shirts outlets. The trial Shirts store in London's Holborn has been operating for six months and is selling twice as much as when it was a Moss Bros outlet.

The group is also planning to reverse the steady slide in its dresswear hire operations. Its market share of around 50 per cent in the 1960s is down to little more than 20 per cent today.

It is also going into an experimental partnership with Hackett, the small upmarket menswear company. A joint store, with hat department and barber shop, will open soon in Covent Garden.

THE CLASSIC

Moss Bros Group Plc

INTERIM REPORT
1988

MOSS BROS
THE DEVELOPMENT

MOSS BROS, COVENT GARDEN

In February 1987, the Secretary of State for the Environment granted detailed planning permission for 54,200 sq.ft. of offices, 36,600 sq.ft. of shopping and 9,300 sq.ft. of separate residential content on the site of the Moss Bros flagship store at the corner of King Street and Bedford Street in London's Covent Garden.

It is proposed to dispose of the freehold site with vacant possession by means of formal tender. The closing date for tenders will be midday on Friday, 27th November 1987.

Notification of acceptance of a tender offer will constitute a binding contract and the prospective purchaser will be required to lodge a 5% deposit with the Vendors' Solicitors, as Stakeholders, within seven days of acceptance.

Completion of the sale will take place on 14th February 1989 when possession of the site will be given.

Interested parties should apply to the Sole Agents, Shearer Harris & Partners, and on payment of £50 (cheques made payable to Moss Bros PLC) they will be sent a detailed information pack containing a full set of drawings and documents.

Vacant possession will be subject to an agreement for lease formalising the occupation by Moss Bros PLC at a rack rent, of a unit totalling 10–12,000 sq.ft. within the completed development.

London Electricity have an existing lease of a sub station within the site

MISREPRESENTATION ACT
All particulars contained herein are for guidance only and do not form part of any contract.

~~SS BROS PLC~~

NEW FLAGSHIP MOSS BROS STORE IN REGENT STREET
OPENING SEPTEMBER 1988

169

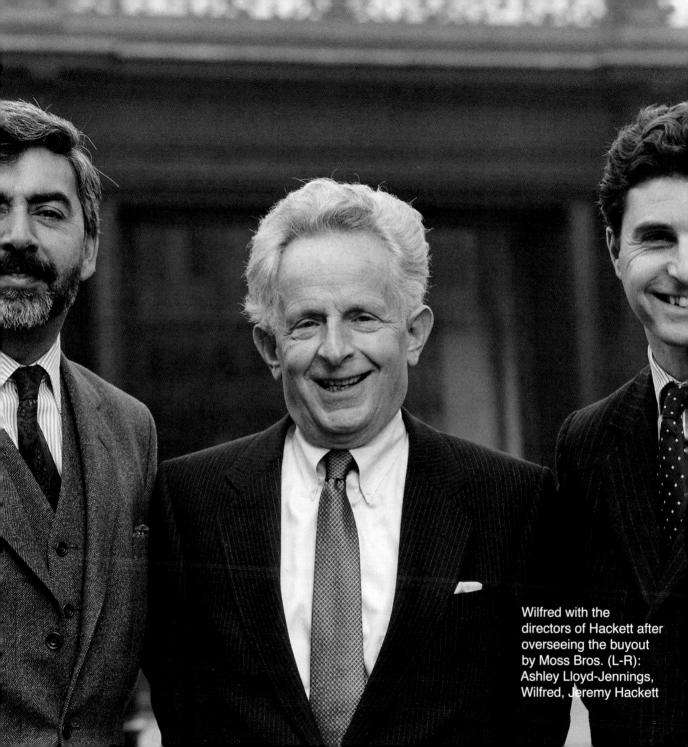

Wilfred with the directors of Hackett after overseeing the buyout by Moss Bros. (L-R): Ashley Lloyd-Jennings, Wilfred, Jeremy Hackett

We also bought the up-and-coming brand Hackett, to give us a bit more of an up-market and modern look, but the two very nice and charismatic individuals who ran it really didn't fit in with the staid Moss Bros. crowd. They eventually decided to go back to their old ways and were bought by one of the big international brand companies.

Across the way from the old Moss Bros. HQ in Covent Garden was an old stamp centre. I think it only had some 4,000 square feet of retail space – compared to over 30,000 in the previous building – but once we had revamped the interior and fitted it out as our main suit-hire centre in London, we found ourselves trading at three times the turnover of the previous shop! Once the profits started rolling in, we were able to open a wonderful new flagship store in Regent Street for the first time.

In 1990, I bowed out of Moss Bros. leaving the much-rejuvenated company in the capable hands of the Gee brothers and the management team I had helped to build. Once again, new horizons were calling: it was time to climb the next mountain.

CHAPTER 11: PLANNING MY RETIREMENT

A Home to Dream in

As Jeannette and I headed towards our seventies together, we knew it was time for a dramatic change. We wanted a new home in the country, and we wanted to create a project together that would not just occupy our time, but become our passion. And in fact, what we found was a place that could make all of these dreams come true – a plot of land that could become both our home and our joint venture in ways we had never imagined.

It was 1990, and Jeannette and I had decided to consolidate our lives. Up to that point, we were happily scattered – the flat in London, a house in Spain, and a cottage in West Sussex. I was still on the board at Moss Bros., and would need to be in London a few times each week, so Spain was no use. And as dear as London will always be to us, leaving the city was the whole point. We enjoyed our cottage in Kingston Gorse, just outside of Chichester – a city we also loved, with the cultural treasures of a place twice its size. So we began looking around West Sussex for a plot of land to build on, since no existing house could possibly fit our strange and stringent requirements!

Our dream home needed to have a view towards the sea, but be high enough up to avoid any danger of flooding, and it would have plentiful grounds for me to walk. Normally when you find such a choice plot in England, it is already crowned with a grand

Hathill Copse house

Georgian manor house – but that is certainly not what we wanted. From a very early age I'd adopted my parents' love for modernism and, in particular, Bauhaus design and architecture, and this was a love that Jeannette and I shared.

The house we wanted would have to be thoroughly modern, full of functional minimalism and well supplied with windows. And so, knowing that good, modern architecture is limited even in urban Britain, nonetheless the countryside, we assumed we'd have to build it ourselves. To that end, we found a plot of beautiful land in the village of Patching, halfway between Brighton and Chichester, and made an offer despite the awful house that currently occupied the plot. It was a weekend, and that coming Monday we were due to pay our first instalment on the offer. On Saturday, I left the Kingston Gorse cottage and went into Chichester where, for the first time in my six decades in this nation, I picked up a copy of *Country Life* magazine. And in that magazine, I saw an ad.

"Hathill Copse, Goodwood, Nr. Chichester, West Sussex" was all the information it gave, along with three photographs of what I instantly recognised as a classic Bauhaus design, full of glorious windows and surrounded by countryside. This was surely the place for us, and it was ready and waiting.

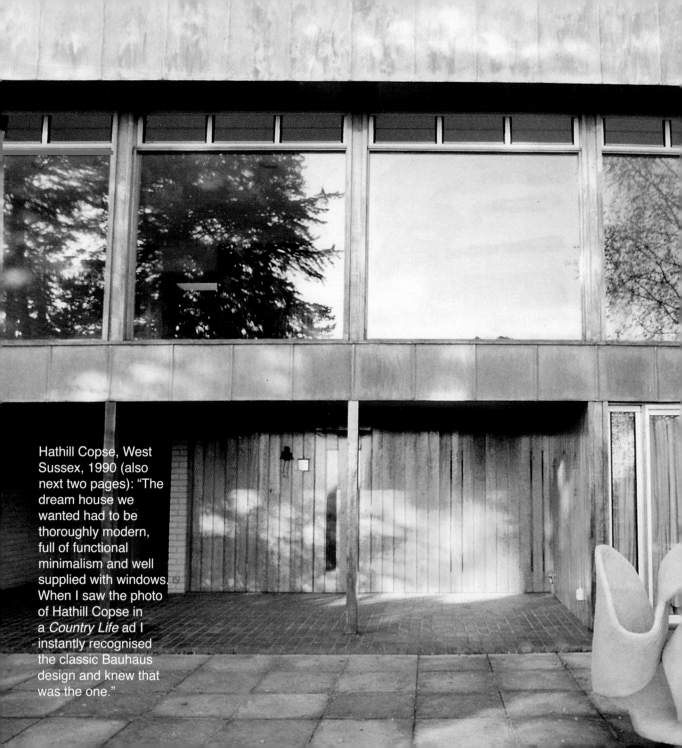

Hathill Copse, West Sussex, 1990 (also next two pages): "The dream house we wanted had to be thoroughly modern, full of functional minimalism and well supplied with windows. When I saw the photo of Hathill Copse in a *Country Life* ad I instantly recognised the classic Bauhaus design and knew that was the one."

The next day we sped out to Goodwood, asking for Hathill Copse – which no one seemed to have heard of. We eventually arrived to discover the previous owner's housekeeper still living there. (Mr Charles Kearley had sadly passed away a few months earlier, leaving some of his magnificent collection of paintings to Pallant House Gallery in Chichester.) That day, with its mad chase around the Sussex countryside, is something of a blur to me. But the housekeeper later reminisced to us that Jeannette and I barely looked at the house, but instead walked around pointing to where we would hang each of our pictures.

Mr Kearley's housekeeper told us that there was an Arab man interested in the house, not for itself, but because he was convinced there was oil in the grounds – which I think there probably is! – and that he had given the estate agent a sum to stop showing the house for a while. The housekeeper was upset because this man's plan was to pave the front into a huge drive, destroying everything. But we quickly learnt that this small, unofficial exchange of hush money was the only deal that had transpired with the buyer; there was no contract at all. That Monday, we made a bid, got out of the Patching deal, and, soon thereafter, Hathill Copse was ours.

Entering the Culture Industry

Perhaps it's the 20/20 vision you get while looking over your own history, but I think that, rather than stumbling upon this glorious house, Hathill Copse found us. Jeannette and I both thought we were heading into retirement. But neither of us is the type to take retirement lying down, so to speak. When I think back on it, we weren't just looking for a new house; we were looking for the next phase of our lives.

Hathill Copse sits at the north-eastern edge of the Goodwood Estate, seat of the Dukes of Richmond and, perhaps more famously these days, home of Goodwood Racecourse and the Festival of Speed. Our predecessor at the house, Mr Kearley, had commissioned the design of Hathill in 1975, done by architects John and Heather Lomax but probably to a plan by, and certainly in the style of, Serge Chermayeff.

Kearley must have had very similar ideas to Jeannette's and mine about what makes a good house. There is plentiful space for beautiful pictures – Kearley had the likes of Cézanne and Severini on his walls. But visit the house once and the main thing you'll remember is the view. The entire southern wall of the main living room looks down a long lawn between the trees, towards

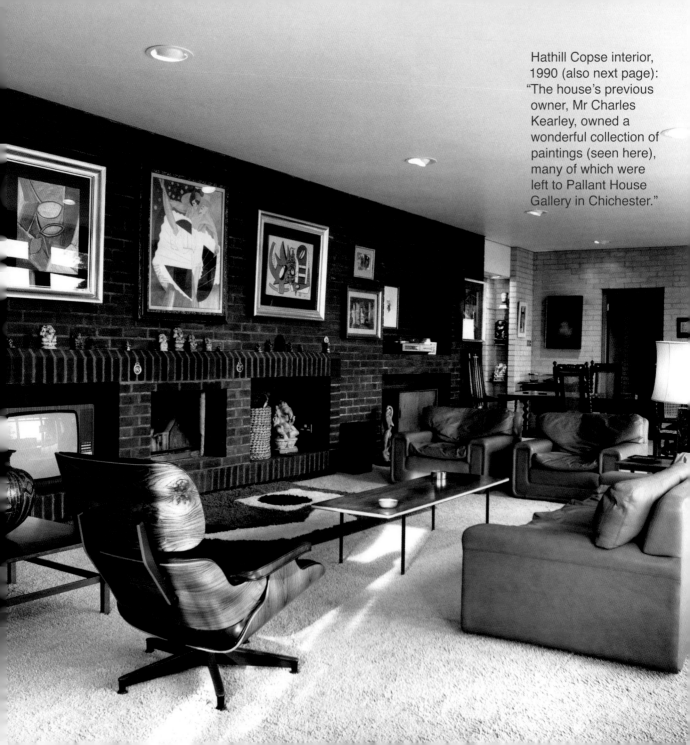

Hathill Copse interior, 1990 (also next page): "The house's previous owner, Mr Charles Kearley, owned a wonderful collection of paintings (seen here), many of which were left to Pallant House Gallery in Chichester."

The Cass grounds

Chichester cathedral and the sea. There is nothing flashy or out of place about the house. It sits harmoniously in its 13-acre plot, sheltered by mature woodland.

We had to raise the money for the house quite quickly, of course, so the Kingston Gorse cottage and the house in Spain had to go. And suddenly Jeannette and I went from multiple residences to one rural home. We went to the theatre a few times each week, and I was in London a few times each week for Moss Bros., but none of it fulfilled what we wanted this so-called retirement to be like.

Surrounding the house, amongst those 13 acres of land, was a long-neglected patch of commercial woodland, which we knew had to be managed. But we also knew that we wanted to do something with that land and with the enormous amount of wood that came from it. In an effort to bring our favourite thing about Chichester a little closer to home, we decided to build a theatre.

It was to be an open-air amphitheatre modelled on the Minack Theatre in Cornwall – a Greek stage carved into the landscape. From our other cultural pursuits, we knew all the right people, and we had passion and energy to spare. We had volunteers from

Wilfred and Jeannette tried their hand at outdoor theatre on the Goodwood grounds, which Wilfred now calls "a disaster"

the Chichester Festival Theatre, and wonderful events including the marvellous actress Doreen Mantle reciting poetry. The only problem was that we didn't understand how theatre worked! In the one season the project was open, we committed sins such as having world-class volunteer directors fetching the tea, and we learned lessons the hard way. For example, it takes a dozen people to move a Bechstein grand piano down to the stage, and, if you're wondering, it's not great theatre to have aircraft from Goodwood aerodrome buzzing down over the actors to see what's going on!

We're not afraid to admit when we've made a mistake, and open-air theatre was clearly not where our true talents lay. After one season, we went back to the drawing board. We still had this land, a little bit of money, and a lot of passion to create something new. I was then – I still am – quite shy, and the theatre world is all about socialising. Perhaps what I needed was something that more directly drew on my previous experiences as engineer, as businessman, as an early adopter. And perhaps what I needed was something that fitted more closely with the Cassirer family history, whether I knew it or not.

When we sold the house in Spain, we brought back to Goodwood one of our prized possessions: a bronze of a horse and rider by the brilliant English sculptor Elisabeth Frink. It's one of the early versions of what would become a signature motif for the artist, whom we were lucky enough to become friends with in the last years of her life. My stockbroker introduced us – he was a neighbour of the Frinks in Dorset, and he knew we were admirers of her work. We bought a number of other pieces from her directly – I remember her hauling bronzes into place in our garden at Goodwood, strong and tireless to the end. As well as the Frinks, Jeannette and I had both collected a few Henry Moore pieces before she and I met, and, of course, I'd known Henry personally since the Reeves days. Now that we had consolidated our living into one house and grounds, we could see these pieces with fresh eyes.

Standing in the main living room, after all our renovations and landscaping had been done, after the open-air theatre had been returned to open-air lawn, Jeannette and I looked out onto acres of land crowned by the work of two of Britain's greatest-ever sculptors. And we knew then and there that this was the way to go. Sculpture was something we both loved, and this was so obviously the perfect place for it. We'd need to learn – about sculpture, and

about the business of sculpture – but that would be a task we'd relish. We didn't know, at that point, if we would buy or borrow the pieces – and, as it turned out, the answer was neither. And we didn't know how we would shape or build our collection and the organisation that would oversee it. But we knew how to find out.

Getting to Grips with Sculpture

In theory, Jeannette and I love sculpture parks: the open air, the marble and bronze dotting a beautiful landscape, the freedom and excitement of it. And we knew that there were some amazing parks in the world. So we began plotting out a pilgrimage that took us not just to the famous locations in the UK – the Yorkshire Sculpture Park, for example, is a treasure – but to Louisiana in Denmark, to Storm King in America, and to similar parks all over the world. And in doing so, we not only stoked our own interest in sculpture, but recognised some very important things that we wanted to do differently.

Walking through the beautiful sculpture park at Louisiana, outside Copenhagen, Jeannette tripped. She put her hand out to steady herself, and found that she was leaning against a sculpture by Isamu Noguchi. She straightened herself out, and in doing so bumped a shoulder against a piece by Brancusi. All this beautiful land, and it was literally crowded with sculpture – so much so

Designing the Foundation's landscape (L to R): Peter Harland (forester), Craig Downie (architect), Victor Shanley (landscape designer), Jeannette Cass (co-founder)

that we couldn't truly understand any individual piece. And we decided at that moment, if we were going to display sculpture at Goodwood, each piece would be in its own setting such that no other sculpture was visible. We would try our utmost to offer the pieces long views like the one we had of our own collection out of our sitting-room window.

Perhaps as important as the way artwork was displayed, we noticed the way these organisations were run. And we didn't like it. These places all had a great number of staff. To do that required more money than any one entity could supply – the result being that they all required outside fundraising. And we were determined not to have any outside money.

We could see how it might be run. Keep it small, stay agile and dynamic and make decisions fast. Get it right, and you wouldn't need lots of curators or staff on the grounds. This was our money we'd be investing, and we knew where we wanted it to go: not to a large curatorial staff, not to constant exhibitions, but to artists making new work.

These other sculpture organisations had lots of employees and huge collections – as Jeannette pointed out at Louisiana, they're

Jeannette during the construction of the Foundation's gallery

getting fuller and fuller. And yet, what they weren't doing is getting *new* sculpture – they're being left collections in people's wills, or buying work that's sitting in the collections of other sculpture organisations. We realised that there are trends in sculpture just as there are in fashion, and we wanted a dynamic collection that changed constantly. Keep the same number of pieces, but by selling some and bringing in new ones. In that way, we could keep the collection ever fresh.

Here's the thing that so many people have a hard time understanding: we didn't set out to do a sculpture park, and that is, in fact, not what we've built. Look at a sculpture park like Storm King in New York – it's wonderful, but you quickly realise that the bulk of the work is 40 or 50 years old. It's heavily subsidised by all sorts of people and foundations, so it's not self-sufficient; not a good financial model for what we wanted. And they're not encouraging artists to make new work – they don't put that money up for artists.

So, once again, we'd have to return to first principles. What did we want to do? Encourage the creation of new work; display sculpture in a way that gives it room to breathe; build an organisation that's self-sufficient financially.

And what were the models for that way of working? There weren't any. We'd have to create an entirely new way of doing things that combined art, business, and entrepreneurship. That's the Cassirer way.

CHAPTER 12: A LEGACY OF PATRONAGE

A Century of Art Entrepreneurship

In 1898, two young men moved to Berlin from Breslau intent on becoming part of the vibrant fin de siècle art world. These cousins opened a bookshop and gallery – *Die Berliner Kunstsalon* (*The Berlin Art Salon)* – as well as a publishing house that bore their names: Bruno and Paul Cassirer. Not long after their arrival in the city, a group of artists broke away from the Association of Berlin Artists because of that body's conservatism. Despite the modern-art excitement exploding all over Europe, Berlin's official arts organisation saw these new trends in art – impressionism, post-impressionism, and almost anything else – as unfit for their galleries and salons. The group of artists who became known as the Berlin Secession walked away from the established art world to do things in the new ways they knew to be the future.

The group's president was the painter Max Liebermann, and that same year he proposed that these two cousins, just arrived from Breslau, be named as the business leaders for the Secession. For three years, Paul and Bruno Cassirer operated as the Berlin Secession artists' representatives, as well as publishers of tracts influential within the group's work.

When Bruno left the group after a falling-out with his cousin Paul, he took the publishing arm of the business with him.

Bruno Cassirer (opposite, in a sketch by Emil Orlik): "My great-uncle Bruno Cassirer was influential enough within Berlin's art world that his daughter, Sophie, was painted twice by the famed Secessionist painter Lovis Corinth. But it was in publishing that he truly made his name – as a child, I would read books such as this one (above), and Bruno would reward me for finding errors."

Bruno Cassirer's immediate family provided him with all the traits necessary for a melding of business and art: his father, Julius Cassirer, had been founder of the cable works that my father later ran, and which was so important to the family's financial stability and history. Bruno's brother, Fritz, was a musician and, more importantly, a conductor. Fritz became a great friend to the composer Frederick Delius, and championed the Englishman's work in Germany. Thanks to Fritz Cassirer and other conductors, Delius found success in Germany before gaining any recognition at home in England.

Bruno Cassirer also sought to champion modern, iconoclastic artists in his publishing business. After leaving the Berlin Secession and taking full control of the publishing house, with an agreement not to compete with his cousin Paul's business in the visual arts, Bruno began publishing *Kunst und Kunstler (Art and Artists)*, an influential journal of arts writing. He also published fiction, philosophy and drama, including Frank Wedekind's play *Pandora's Box* which led to a famous obscenity trial. But I recall Bruno quite differently from the stereotype you might expect of a man who published drastically avant-garde literature. He was a family man and very good with children. As a boy, I can remember him sitting me down over galley proofs of his books, offering me

Vincent van Gogh,
"Portrait of a young man
(Armand Roulin)", 1888

prizes if I could find mistakes in them. While I wasn't too interested in spelling or grammar, I was very interested in toys, and often discovered more errors than anyone would have thought a child could find!

In the early 20th century, Bruno was influential enough within Berlin's art world that his daughter, Sophie, was twice painted by the famed Secessionist painter Lovis Corinth. But his cousin Paul Cassirer was more influential still. After the cousins split, Paul took over the gallery and continued to support the Berlin Secession artists and to promote other European artists working in modern styles. He was the first to present exhibitions of Van Gogh and Cézanne in Germany, and became a major champion of Berlin painters Liebermann and Corinth. Interestingly, Paul Cassirer was particularly notable as a champion of the sculptors Ernst Barlach and August Gaul – in 1911, Gaul's *Duck Fountain* was funded by Paul's relative Max Cassirer and installed in Charlottenberg, the first of that sculptor's works to appear in Berlin.

But despite his success as a dealer and gallerist, Paul Cassirer's life was a tormented one. In 1919, his son, Peter, committed suicide before returning from service in the Great War. Paul's second marriage was to the extremely famous and beloved

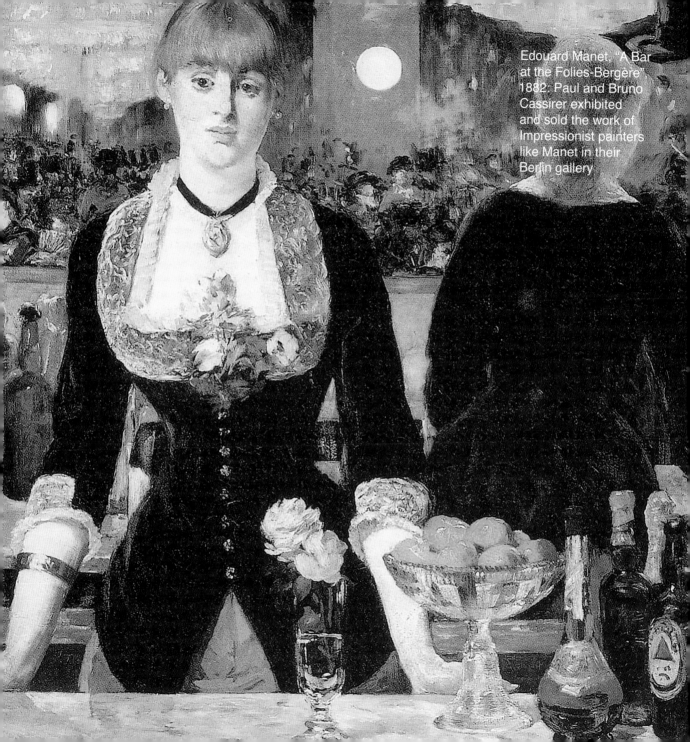

Edouard Manet. "A Bar at the Folies-Bergère" 1882: Paul and Bruno Cassirer exhibited and sold the work of Impressionist painters like Manet in their Berlin gallery

Emil Orlik, "Paul Cassirer"
(date unknown)

actress Tilla Durieux. She was considered one of the great beauties of her day; beautiful enough to inspire Renoir to paint her portrait.

But their marriage was tumultuous at the best of times, and in 1926 Durieux and Cassirer divorced. At the meeting to finalise the divorce, Paul Cassirer signed the papers, excused himself, walked into the next room, took out a pistol and shot himself dead.

Paul and Bruno's influential artistic taste reached far across the Cassirer family tree. In 1900, Bruno's father, Julius Cassirer of the cable works, bought an extremely important impressionist masterpiece: Pissarro's "Rue de Saint Honoré", which today hangs in a museum in Madrid. The painting was seized by the Nazis from Julius' descendants, and despite years of claims from the family, has never been returned to Cassirer hands.

As I see it, the legacy of Bruno and Paul Cassirer isn't a string of paintings or publications, nor yet a series of long-forgotten art world scandals. It's the idea that new artwork requires new models for production and distribution. Jeannette and I tapped into this legacy when we decided to use our retirement years to build a new model for the art world. The idea that would eventually

become the Cass Sculpture Foundation began just as Paul and Bruno Cassirer's ideas did: with a passion for art and a frustration with the models currently available for providing patronage and a little push to artists.

If the model that exists to support artists creating new art doesn't work, you've got to come up with a new model. It sounds simple – it should be obvious. But just like in other businesses, when people have done things one way for a long time, it's hard to convince them it might be otherwise.

CHAPTER 13: THE BIRTH OF THE CASS SCULPTURE FOUNDATION

Super Model

The Cass Sculpture Foundation model is somewhere in between the traditional roles of an art gallery and a not-for-profit art funding organisation. The Foundation doesn't buy sculptures, but commissions them directly in such a way that the artists share in both the risks and the rewards of the process. We work with artists to determine what ideas of the highest quality they have always wanted to realise, but are unable to because the scale or fabrication method is too ambitious for their budget. Then the Foundation pays for all the costs of building the work: materials, fabrication, transport – everything, in fact, except the artist's own fee. We install the finished artwork in our grounds and work to sell it. The profits from the sale are then split 50/50, with half going to the artist and half going back into the Foundation's purse to commission other work.

We planned on commissioning 10-20 new works per year, and selling them, and that's more or less how things have worked out. But the model is flexible – in down times, like the recession that began in 2008, we sell fewer pieces, and so we commission fewer pieces. But in our first 20 years, we commissioned more than 300 new artworks, and borrowed and displayed for sale around a hundred further pieces. That's roughly equivalent to one every two and a half weeks – not bad for upstarts!

The Foundation isn't a sculpture park, because we're not collecting artwork and keeping it forever. To keep commissioning new work, and to keep the 'gallery' at Goodwood fresh, we have to sell the work we already have – it needs to change over, and we need to replenish the coffers. But just like the Berlin Secessionist Cassirers, what that model allows us to do is to help artists speculate – help them to do something they never imagined possible, because it was too big, too expensive, too new.

First Steps

I saw Thomas Heatherwick's "Pavilion" at the Islington Art Fair in London in 1992. At the time, Tom was only 22 years old and built the piece for his degree show: "Pavilion" turned out to be a statement of purpose. He was a designer, working with architectural and industrial ideas and materials, but with the artist's keen eye towards repurposing technologies and building something new that broke across boundaries of art, design, architecture, and craft. It was everything I wanted to represent the Cass Sculpture Foundation, and despite him being a young, relatively unknown designer, I knew that this piece and this artist had to come to Goodwood.

We made contact with Tom, and brought him to the house, where he rebuilt "Pavilion" in a small clearing surrounded by woods and wildflowers. More than that, we installed the young man and his

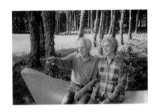

Wilfred & Jeannette, 1993

Thomas Heatherwick, "Pavilion", 1992 – one of the Cass Foundation's first discoveries

assistant in our garage for three months, designing and building benches for the soon-to-open Foundation. This was long before worldwide fame came to Tom in the 21st century thanks to his design for the extraordinary cauldron that held the flame for the Olympic games in London. Our relationship with Tom was not only one of our first outings, I think it was one of our first major successes, discovering an artist who would go on to be a household name.

"Pavilion" stands on the grounds to this day, and despite the fact that we didn't commission its initial design, I consider it to be the first piece to embody the Cass Sculpture Foundation's mission: to commission new monumental sculpture from emerging as well as established artists. But perhaps more than that, I recognise in "Pavilion" a lot of the traits that the Foundation inherits from my own approach and from the Cassirer history. It pays no heed to previously conceived boundaries between disciplines. "Pavilion" lets the world of contemporary avant-garde art mingle with those of engineering and industry, just as the Foundation blurs the lines between gallery, open-air sculpture park, and not-for-profit, artist-driven commissioning organisation.

It's probably Sir Anthony Caro who first put his finger on what our mission had to be: most artists, even the most successful ones,

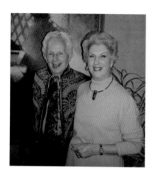

Wilfred and Jeannette hosting a party at home in Goodwood

Anthony Caro, "Tower of Discovery", 1991

he said, tend not to speculate. What we want to do for the artists we think are great, or have the potential to be great, is speculate *for* them. Not surprisingly, Tony Caro was one of the first major, established artists that the Foundation approached. Jeannette and I met with Tony in Rome and convinced him to come and visit Goodwood. Walking the grounds, Caro said to me, "I do have one work – my most ambitious to date, currently in Spain. It could come here, but you would need to build a new road…" I turned to him, and simply said, "Tell me when you need the road."

The rest of the story of Caro's "Tower of Discovery" is a bit like our discovery and purchase of Hathill Copse house. We discussed the "Tower" with Caro on a Saturday; on Sunday and Monday, the road was built; and on Tuesday, the artist's most ambitious piece to date was installed on our grounds.

Our relationship with Tony Caro flourished, and a few years later he developed "Goodwood Steps" for us, which we installed just outside the gates to the Foundation. For that, we needed planning permission from the council, which we were denied. As you might have guessed, I went ahead and began building anyway, knowing it would take years for the council to prosecute and by then we'd have the situation sorted out. It turned out the planners thought that something like a Henry Moore would've been fine, but this

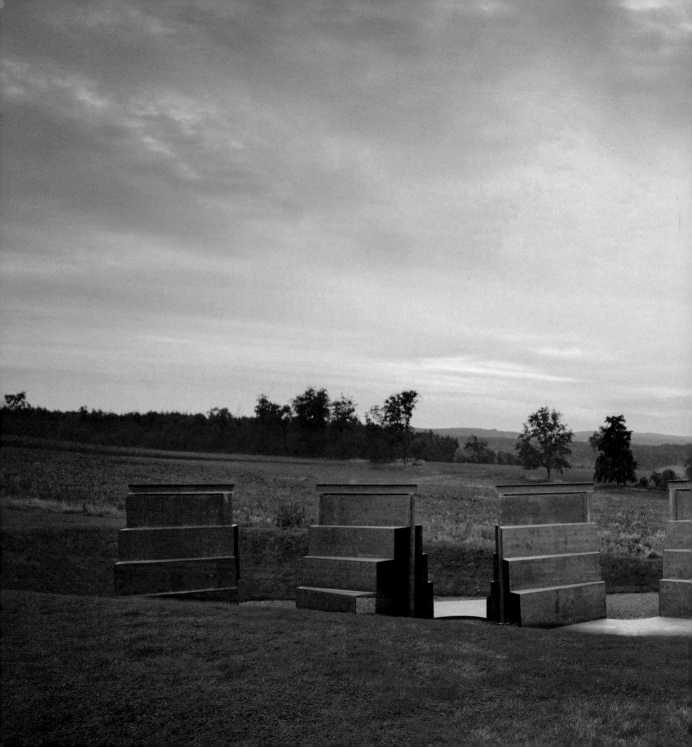

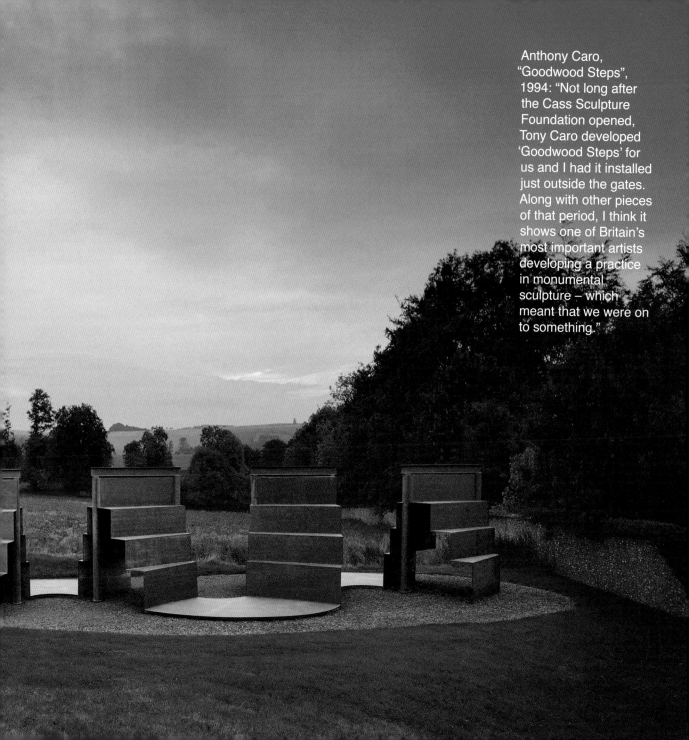

Anthony Caro, "Goodwood Steps", 1994: "Not long after the Cass Sculpture Foundation opened, Tony Caro developed 'Goodwood Steps' for us and I had it installed just outside the gates. Along with other pieces of that period, I think it shows one of Britain's most important artists developing a practice in monumental sculpture – which meant that we were on to something."

Caro fellow was an unknown. (No matter that he'd already been knighted for his incomparable service to British art.) After more than 150 letters were sent to the planners – solicited by us from friends and supporters who all testified to Caro's vital place in British art history – they practically begged to give us permission, just to stop the letters!

"Goodwood Steps", "Tower of Discovery" and "Pavilion" represent the turning towards a monumental, architectural, and engineering approach to sculpture in the landscape by two of Britain's most important modern artists. That the Cass Foundation began with these artists, amongst many others, showed that we were on to something right from the beginning. "Tower of Discovery" was quickly purchased by The Museum of Contemporary Art in Tokyo as part of that centre's opening collection, and "Goodwood Steps" has been shown in many locations since its creation.

Doing Things Our Way

In the very earliest of days, the Cass Sculpture Foundation was, essentially, Jeannette and I with a computer and a telephone in the small blue study at the eastern end of our house. Soon after officially establishing the Foundation in 1992, we engaged a secretary (Marion Whitcomb), our first volunteer (Janet Tucker (nee Kahn, who was terrific), and our Arts Council England-funded director Ann Elliot (who later started the ball rolling for

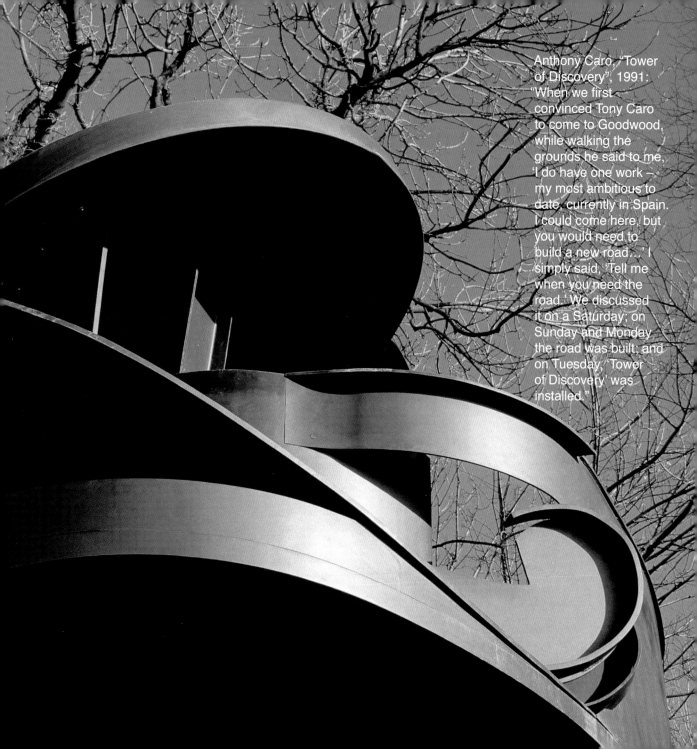

Anthony Caro, "Tower of Discovery", 1991: "When we first convinced Tony Caro to come to Goodwood, while walking the grounds he said to me, 'I do have one work — my most ambitious to date, currently in Spain. I could come here, but you would need to build a new road…' I simply said, 'Tell me when you need the road.' We discussed it on a Saturday; on Sunday and Monday the road was built; and on Tuesday, 'Tower of Discovery' was installed."

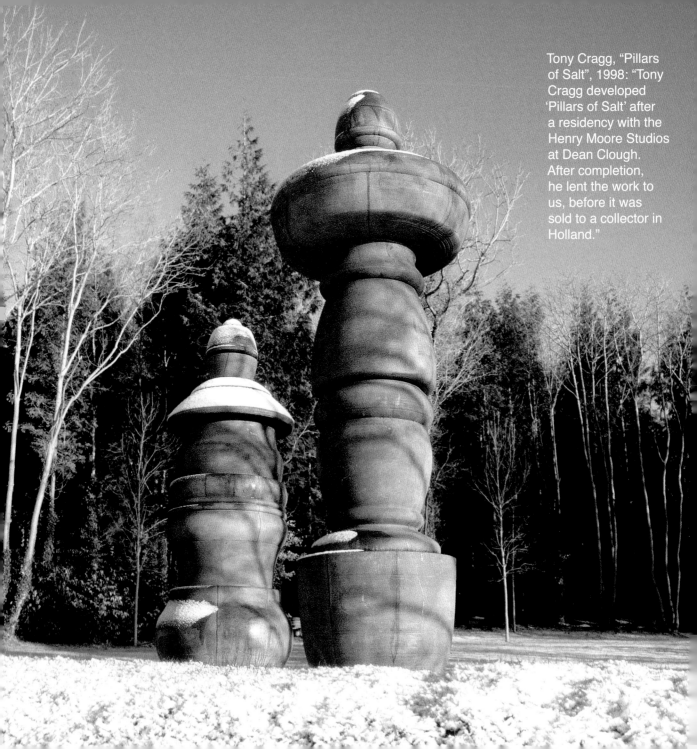

Tony Cragg, "Pillars of Salt", 1998: "Tony Cragg developed 'Pillars of Salt' after a residency with the Henry Moore Studios at Dean Clough. After completion, he lent the work to us, before it was sold to a collector in Holland."

this book, with her research into my Cassirer ancestors). During that early period, we were making the decisions that would determine the future of the Foundation – setting up the model and commissioning system, establishing the finances, and making curatorial decisions such as Caro, Heatherwick and Cragg that would become our statement of purpose.

Our initial learning curve was a steep one. Jeannette and I had to learn the sculpture language, who was who and what was what, and being in our seventies, we didn't think we could learn the whole world! So in the beginning we limited our interests to contemporary British sculpture, which, at the time, wasn't particularly trendy and seemed like a risky investment to many. This decision entailed some major sacrifices; for example, it ruled out the possibility of working with my brother Eric, who already had a particularly fine collection of 20th century European sculpture. Eric and his wife Jean had followed in our Cassirer forbears' footsteps to become major patrons. Over the course of 40 years they amassed an amazing art collection. Then in 2012, they gave the bulk of it away to public galleries and museums across the UK – a gift of more than 300 artworks collectively worth over £4 million. It was a wonderful gesture of generosity. But the traditional collector model wasn't the route for me; I had to find my own way to make my mark.

Elisabeth Frink,
"Horse & Rider"

The Cass Foundation's commissioning model sounds simple now, and almost obvious, but in 1992, when Jeannette and I began to host a series of lunches and dinners with the great and the good of the British art world to tell them about this new idea, there were many people who said it would never work, that it would be a 'white elephant'. People thought the work would not sell, that we would lose every penny we invested in the project. This is what happens with a new model in the arts – people know the way non-profit sculpture parks work, funded by dozens of outside grants, and they know the way that a gallery works, selling the safe bets (and certainly not sculptures that take up a quarter of an acre!). But they see a new idea, and can't imagine it becoming normal.

Fortunately, there were also some voices telling us to move forward. Tony Caro was a supporter from the very beginning, as were Peter Murray of the Yorkshire Sculpture Park and David Mitcheson of the Henry Moore Foundation. They were so supportive, in fact, that they got sick of hearing about it: "Stop talking, start working" was their message! And that's just what we did.

The first tough decision was that the beloved Henry Moore and Elisabeth Frink sculptures that Jeannette and I had collected did not fit into the Foundation's concept of commissioning and

encouraging new sculpture. All the more difficult because Frink in particular had become a great friend, and was a regular visitor to Hathill Copse before her tragic death in 1993. But however much we loved them, we couldn't move all of these large pieces into our house. Looking back on it, what we did then was a rather bold decision: our first move as a brand-new arts organisation specialising in British sculpture was to *sell* work by two of the medium's greatest-ever practitioners. If that didn't broadcast to the art world that this was going to be a completely new sort of sculpture park, then I'm not sure what would!

Moreover, we needed the money from the sale of our Moores, Frinks, and the like to fund the work that started the Foundation, make those first purchases and commissions, and, importantly, build the open-air gallery concept in our South Downs landscape.

For the latter task, we turned to the award-winning garden designer Victor Shanley and forester Peter Harland, who worked with our own grounds manager Martin Russell. Our neighbour the Duke of Richmond had very generously granted us another dozen acres of Goodwood Estate land, which we added to ten acres of our own and turned over to the Foundation's use. And we used it to the full. Harland built 60 open-air galleries, with an eye towards our goal of having each sculpture 'breathe' within its

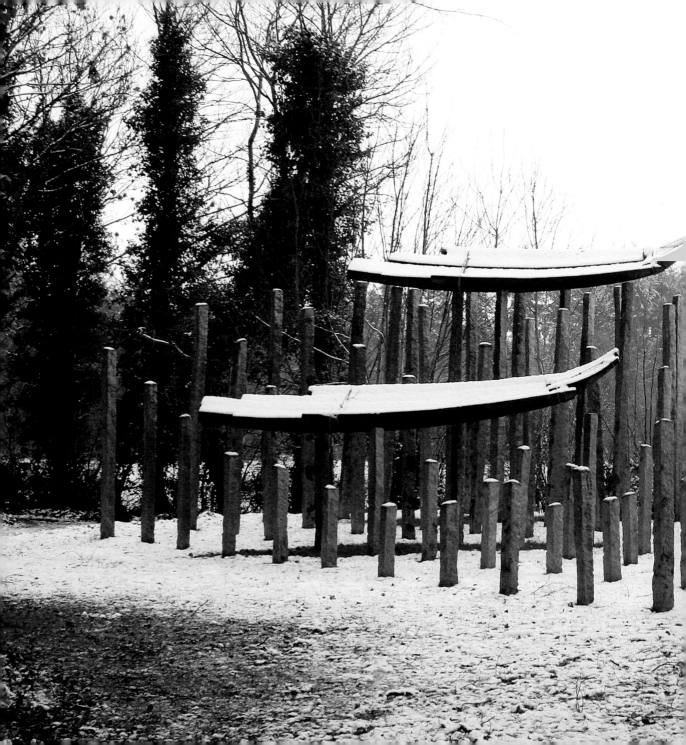

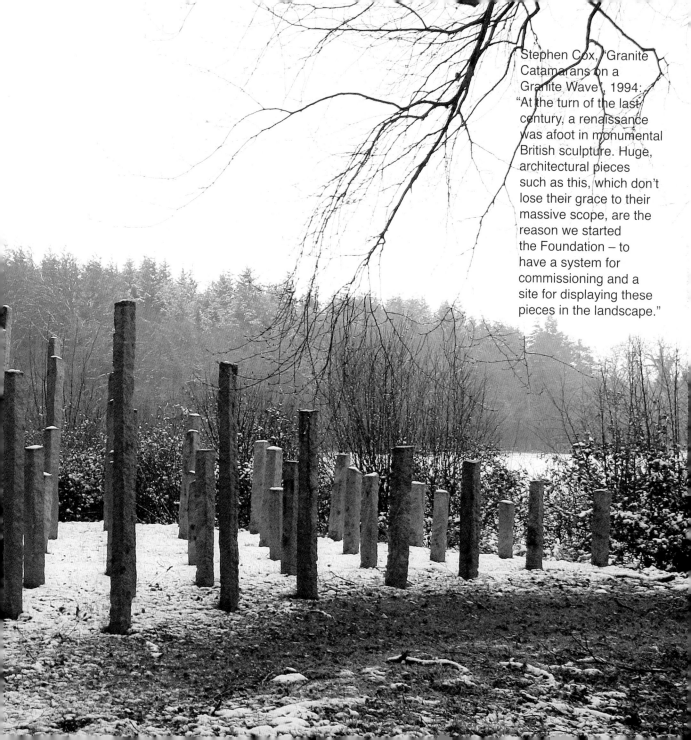

Stephen Cox, 'Granite Catamarans on a Granite Wave', 1994: "At the turn of the last century, a renaissance was afoot in monumental British sculpture. Huge, architectural pieces such as this, which don't lose their grace to their massive scope, are the reason we started the Foundation – to have a system for commissioning and a site for displaying these pieces in the landscape."

own dedicated space, by removing clumps of trees to allow the sun to shine onto small, isolated clearings. Meanwhile, Shanley, Jeannette and I travelled to Italy and bought thousands of shrubs and trees, which Victor and his horticultural students planted on our grounds to his design plans. We commissioned the architect Craig Downie to design an elegant visitors' centre, and built it in four weeks flat.

Making Ideas into Reality

Those early days of the Foundation were a constant whirlwind – meeting artists, holding events to introduce ourselves, our space, and our sculptures to the art world, commissioning and building the Foundation's reputation. It's important to keep in mind that the process of commissioning a monumental sculpture, from agreeing the concept, to sourcing materials and labour, to building and installing the piece, isn't usually a quick one. But the Foundation was a beehive of activity. In 1993 we commissioned over a dozen pieces, and less than a year later they were all on site, and for sale.

We had hoped that, once our reputation began to grow, artists would seek us out. But for the most part, the commissioning process has remained similar to its very beginnings, which starts out with us approaching an artist. We've always run Cass Sculpture Foundation like a mom-and-pop shop: we

Bill Woodrow, "Endeavour: Cannon dredged from the first wreck of the Ship of Fools", 1995

see everything, sign the cheques, approve the design for the brochures. Really, until the time of writing this book, just about every item of Foundation business has crossed my desk. The commissioning process is like that, too, and I have found it really important for Jeannette and I to be very hands-on in order to maintain the Foundation's ethos. Our level of involvement is starting to change now, as the Foundation moves forward to the next stage of its development. But until very recently, we have been with the artists every step of the way.

From the start we began networking – meeting journalists, arts writers, curators, artists – and learning about whom we might work with; I still do that. When we have decided to work with an artist, or at least potentially work with an artist, I'll say to him or her, "There must have been some piece in your career that you've imagined but, because of its size and cost, you can't afford to do it, and your gallery won't do it." We'll look at drawings or a maquette and in many cases, when we see one we like, we go straight ahead and do it. One such example is Bill Woodrow's first piece for us, "Endeavour: Cannon dredged from the first wreck of the Ship of Fools": he handed me drawings of a cannon, and I said, "Let's do it." I hate meetings, I hate going over things again and again, I just want to make the decision that very day and give the go ahead.

Ana Maria Pacheco, "Requiem", 1995. "Brazil-born sculptor Pacheco had been working on this piece for nearly a decade when we commissioned her to realize the beautiful sculpture of her father."

Victor Timofeev, "X", 2013: "Victor had never made a piece of sculpture before we commissioned him to build 'X'. But we knew from his architecture-inspired 2-D artwork that he had the potential, so the Foundation guided him through the entire design and fabrication process. And now he's as thrilled with the piece as we are."

Once we give the go-ahead, the work we do with the artist depends on his or her needs. Some of our artists are very experienced; some have never made sculpture on a large scale before, and a few have never even made small-scale sculpture. As I write this, one of the newest pieces we've installed is Latvia-born artist Victor Timofeev's 2013 piece "X", which currently marks the spot where visitors enter our grounds. While Timofeev is a rising star of the art world for his drawings and collages, he had never made sculpture of any kind before we commissioned him. We spotted his very contemporary-architecture influenced drawings and determined he was a good choice for a young artist to guide through the creation of a monumental sculpture. We helped him learn how to produce the appropriate drawings and work out the process; to find the fabricators, build, and install the piece. Happily, Timofeev is as thrilled with "X" as we are and wants to do more and more sculpture.

In the rest of the art world, most large commissions are never shown – they go into a building or private collection as soon as they're completed. Obviously most of the sculptures we commission would otherwise never be built. But more than that, not only do we build them, we show them publicly in a highly regarded space to which people come *specifically* to see monumental sculpture. We pay for the engineering and building of

Andy Goldsworthy, "Arch at Goodwood", 2002: "Goldsworthy made several arches for the Foundation's grounds, of which this is the most imposing. One of the artist's largest-ever pieces, it spans the 18th century walls that surround Goodwood."

the piece, its transportation and installation, but the artist isn't paid until the sculpture sells. So there is some risk for the artist, but it's not much, because the piece would otherwise simply not exist!

The most exciting moment for me is the installation of a new piece of sculpture. Today, at 88 years old, I still go outside whenever I can to watch our little green forklift truck Hugo (which I bought for myself as an 80th birthday present) haul the heavy form into position. It's the moment when everything comes together: the artist's vision, the long months of problem solving with the engineers and fabricators, the hard work by the whole team at Goodwood. Tonnes of bronze, steel or marble seem to float effortlessly in space, and I see the idea becoming solid reality at last. In the mid 1990s, that feeling was even more exciting, because our first fully, independently commissioned pieces were coming in. We were installing works by the likes of Woodrow, Caro, Andy Goldsworthy, Lynn Chadwick, Cathy DeMonchaux and William Tucker on a regular basis.

For me, everything about the Foundation was personally important, and while it has been the most work – and the longest-lasting single job – of my life, every single day is an exciting experience. Working with incredible artists like these is electric; the completion of a project, beginning of a new one, or sale of a sculpture is like

Lynn Chadwick, "Ace of Diamonds III", 2004: "This was one of the last pieces Chadwick completed before his death. Jeannette and I visited him and his wife Eva in 2003, and immediately commissioned this sculpture from a small-scale maquette. Chadwick died later that year, without realising his ambition to see the finished work."

a fountain of youth to me. And it goes without saying that, as we saw our exciting new model for commissioning, displaying, and selling artwork begin to take off, we wanted the Foundation to grow.

There was one major constriction that kept us from growing in the mid 1990s. Our financial model was forward-looking and safe – it would keep the Foundation commissioning and growing slowly for years to come, based on the fact that commissions were tied to sales, keeping us from needing outside funding. But even in the late 1990s, when sales were ticking along nicely, that model didn't allow for a sudden burst of growth.

Taking Cash Out of the Bank

By 1999, I had been in what I laughingly refer to as 'retirement' for nearly ten years. In 1989 I'd stepped down from Image Bank, and around 1990 I left my position on the board at Moss. But after that quiet decade of doing nothing but dreaming up and enacting a major new model for the commissioning of massive artworks, my son Mark came to me and said that he'd had an offer. He could move to New York City and run all 500 of Image Bank's photographers, which he thought seemed like an interesting move for him, and a smart investment of his time for our Image Bank business. Why did he come to me? Because he wanted me to step back in and run things on the UK side while he was gone.

Thinking Big: Concepts for Twenty-First Century British Sculpture at Peggy Guggenheim Collection, Venice, 2002-2003 (above and next page): "Our tenth-anniversary exhibition included 85 maquettes of our commissions. The architect Lord Norman Foster (next page, center) opened the exhibition, which more than 100,000 people viewed, pushing the Foundation forward into the international art spotlight."

I brought in Guy Topham, who had been my finance director back in my days at Reeves, and together we set out a plan to make the business as profitable as possible in order to sell it within just a few years, so that I could get back to working at my new passion, the Foundation. By concentrating on the bottom line, reducing costs and driving sales activity, we succeeded more quickly than I'd even hoped, taking less than three years to begin the sale of The Image Bank to Getty Images. Now, finally, I would have the kind of money I wanted to be able to invest in expanding and marketing the Foundation.

This same turn-of-the-century period was a very fruitful moment for the Foundation's involvement in the broader British art world. A renaissance was afoot in monumental British sculpture, at a time when works like Anthony Gormley's "Angel of the North" were making headline news. And even as I was overseeing the turnaround at Image Bank, Jeannette and I were playing a key part in that renaissance.

Edward Allington David Annesley John Atkin Oliver Barratt Glenys Barton Zadok Ben David
Ivan Black Willard Boepple Jon Buck Peter Burke Anthony Caro Ann Christopher
Tony Cragg George Cutts Grenville Davey John Davies Pierre Degen Abigail Fallis
John Gibbons Andy Goldsworthy Steven Gregory Charles Hadcock Nigel Hall
Peter Hide Simon Hitchens Shirazeh Houshiary Jon Isherwood Allen Jones Vichai
Danny Lane Langlands & Bell William London Billy Lee Liliane Lijn Peter Logan
Martin & Dowling Barry Mason Sally Matthews Charlotte Mayer Dhruva Mistry
Peter Newman Alastair Noble Eilis O'Connell Zora Palova Tom Phillips William Pye
Keith Rand Peter Randall-Page Michael Sandle Lucien Simon William Tucker Marcus Vergette
Rob Ward Richard Wentworth Gillian White Rachel Whiteread Richard Wilson Bill Woodrow

thinking big

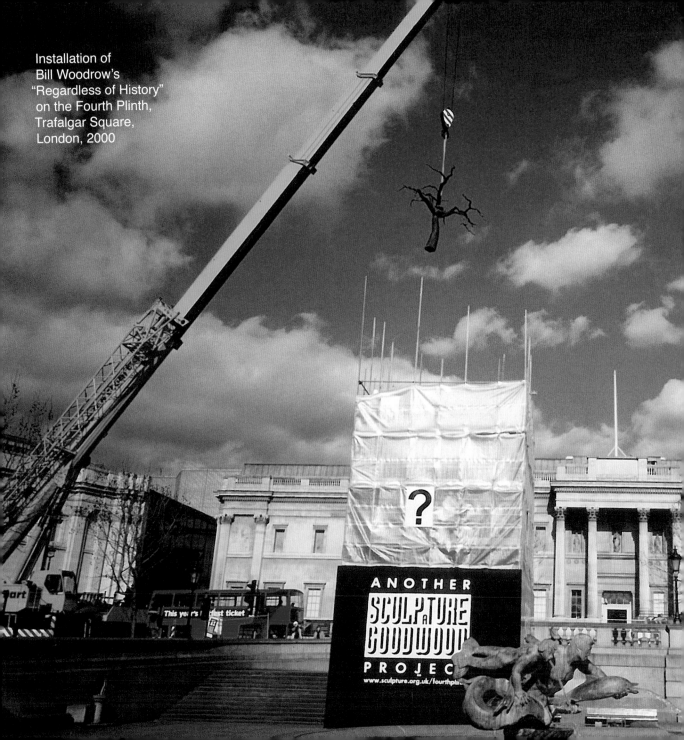

Installation of
Bill Woodrow's
"Regardless of History"
on the Fourth Plinth,
Trafalgar Square,
London, 2000

CHAPTER 14: THE FOUNDATION BRANCHES OUT

Plinth Charming

In 1998, the Royal Society of Arts convened a project to commission new sculptures from some of Britain's most influential artists. These would occupy one of the most high-profile outdoor sites in London: the plinth that sits in the northwest corner of Trafalgar Square. Unlike its three counterparts, the fourth plinth had long sat empty. Prue Leith, then Chair of the RSA, who had originated the idea and spent years setting it in motion, visited us at Goodwood and recognised that no one else was as expert in the commissioning of new works of this sort. What's more, she saw that our funding model could work for her project too. So Jeannette and I were asked to join the committee curating the Fourth Plinth project, along with Sandy Nairne from the Tate, and Artangel's James Lingwood.

The first piece we commissioned for the Fourth Plinth was Mark Wallinger's "Ecce Homo", a life-size figure representing Christ, which made a quiet but affecting impression in contrast to the heroic bronzes on the other plinths. It was successful enough that our committee curated two subsequent installations: Bill Woodrow's striking bronze "Regardless of History" and Rachel Whiteread's "Monument". The latter was the most innovative of the three, and also the work that most polarised people's opinions: a clear resin piece that mirrored the size and

Rachel Whiteread,
"Monument", 2001

shape of the plinth below, using a casting technique that had never before been attempted on such a large scale. While all three of these very different works divided both public and critical opinion, each of the sculptures was successful in its own way, and they generated a buzz that no one could deny. Thanks to the public interest generated by our commissions, the Fourth Plinth idea was picked up by the Mayor of London's office and carries on to this day.

As I write, Woodrow's "Regardless of History", which the Foundation funded, is still on display at Goodwood. We don't have Whiteread's "Monument" but we did buy one of the very limited editions of the maquette of this internationally known sculpture. It resides in one of the most exciting but least known parts of the Sculpture Foundation: our extensive archive.

A Room Full of Treasures

When we are first looking to work with an artist, we'll often be shown drawings or a maquette of what the artist would like to make. Through the process of designing the sculpture, sometimes we'll receive further drawings or maquettes from the artist. And regardless of what happens with the final product, these work-in-progress pieces are kept by the Foundation in a vault-like, white-walled annex. A visiting art consultant once called it my

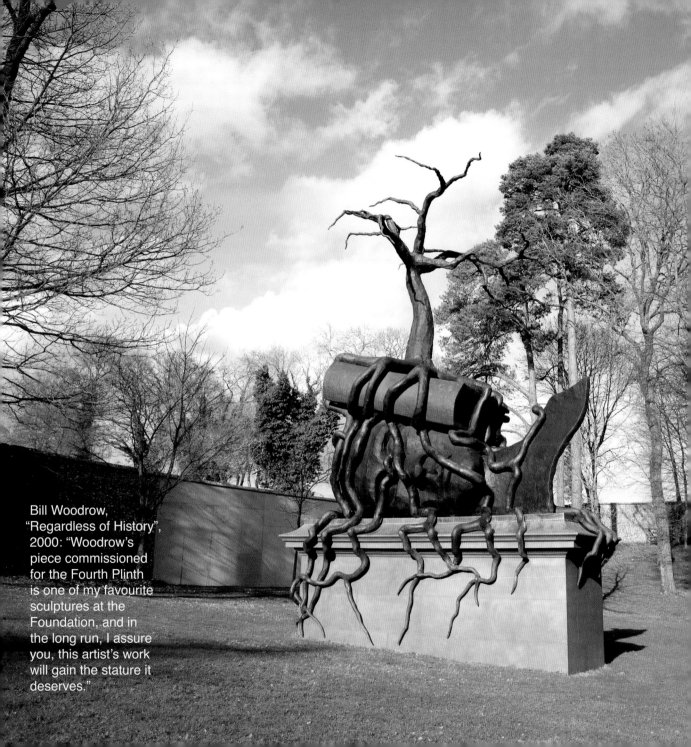

Bill Woodrow, "Regardless of History", 2000: "Woodrow's piece commissioned for the Fourth Plinth is one of my favourite sculptures at the Foundation, and in the long run, I assure you, this artist's work will gain the stature it deserves."

Architect Craig Downie designed the new building for the Foundation Centre in 2007

Kunstkammer (a word you might translate as "Cabinet of Art"), but we simply call it the Archive. When we first put together the Archive, in 2005 at the time that the Foundation Centre building (designed, like the original visitors' centre, by Studio Downie Architects) was opened, we weren't taking much care with these historically and artistically important objects. In fact, some of the maquettes came out from under my bed, where they'd been unceremoniously stored!

Walk into the Archive today and you're confronted with person-sized racks of sketches, blueprints, and posters; hundreds of feet of shelving holds scores of maquettes; specimen drawers contain every poster, letter, or piece of paper associated with the Foundation, its artists, and its commissioning processes. In the Archive you'll find a miniature Fourth Plinth topped with the maquette of Rachel Whiteread's "Monument" and, just a few feet away, similarly important pieces by the likes of Lynn Chadwick, Marc Quinn, and Eduardo Paolozzi.

With the Archive, Cass Sculpture Foundation has the ability to maintain a historical collection while still avoiding the behind-the-times syndrome that so many sculpture organisations suffer from. In the Archive, you practically trip over 20 years of the history of

Chip off the OLD BLOCK

HAPPILY, THE BRITISH SCULPTURE SCENE IS IN RUDE HEALTH, BUT THERE IS ONLY ONE PLACE WHERE WORKS FROM BOTH EMERGING AND ESTABLISHED ARTISTS COME TOGETHER. *WILFRED CASS* WRITES ABOUT HIS ARTISTIC IDYLL IN SUSSEX

my wife and myself. As we're quite a small operation, we can turn on a pin. There is always either a new piece coming in or going out or being shown somewhere. We recently showed, for example, a piece by Ellis O'Connell called The Loop in front of the new Wembley Stadium for the FA Cup Final. Around 60 per cent of all works go overseas to America, Japan and Germany. We've just sold seven pieces to a Portuguese multi-billionaire called José Berardo who's opening a museum in Lisbon. He took four or five of what I'd call our best pieces; luckily he didn't take them all.

Unlike the rest of the art world, where prices are withheld till your bank account has been checked, we give everyone a price list. The range goes from a few thousand pounds for the maquettes we sell in the shop to a Bill Woodrow at the top-end, which costs

> *If a major piece sells, we've got to struggle to get another artist who can do something of the same calibre*

about £800,000. The average price is around £100,000. You could get a Tony Cragg for £200,000 or £300,000. There's a solo Cragg exhibition on here now; we have 12 pieces, including some produced for the exhibition.

I don't get emotionally attached to the sculptures. There's a canvas of 72 pieces in 20 acres and we're trying to create a changing picture with them. If a major piece sells, we've got to struggle to get another artist who's going to do something of the same calibre. We're always moving forwards. We don't keep the woodland static; we landscape the grounds in relation to the pieces.

I'm immensely proud of the fact that quite a few artists are on the road to being important as a result of working here. Tom Heatherwick for one; we own his graduation piece. Andy Goldsworthy did quite a lot of early work here. We've done experimental

The very best of 21st-century British sculpture at Goodwood. Clockwise from far left: *Arian Form* by Terrence Coventry; *Widow* by Sally Matthews; *Confessional* by Cathy de Monchaux; *Icarus Palm* by Douglas White; *Jane Ackroyd's Wildebeest; Sycamore* by Windy Taylor; *London to Paris* by Sir Eduardo Paolozzi; *Eastern* by Sir Anthony Caro; and *Carapace* by Ellis O'Connell

work with Sir Anthony Caro. Cathy de Monchaux has got a great big piece here, *Confessional*, with which she probably should have won the Turner Prize.

Quite often we get artists at the start of their careers, but not always. We only worked with Marc Quinn in 2003, when he created a 12-metre metal orchid, *The Overwhelming World of Desire* (Paphiopedilum Winston Churchill Hybrid).

I couldn't be specific about when I became interested in sculpture. I come from a German-Jewish family that was very much involved in the arts; my great-uncle Paul Cassirer was the most important dealer for the Impressionists in Europe. So I think it's

in the genes. I got to know the late Henry Moore quite well and talking to him over the years – he was always very generous with his time – doubtless got me interested in sculpture, albeit subconsciously.

I am 82 now and the Foundation keeps me going. I've probably got far too much energy; I'm always moving pieces around and constantly working to make the piece look better; it's our commitment to the artists. I never stop learning what the market is all about. It's a small world but quite complex.

We don't stage big shows. We don't have to curate anything. I just have to choose one or two new sculptures every four to six weeks, which then take one or two years to

produce and install in the ground. Over the past 12 years, we've commissioned more than 140 large-scale sculptures from over 120 British artists.

We get around 10,000 paying visitors a year. But not enough people know about us – the art world is still based, more or less, completely around London and it's a day out to come here. But those who do come always say they absolutely love it and want to visit again. Once you get people down here, there's absolutely no problem. It's a simple idea in beautiful grounds.

The Cass Sculpture Foundation in Goodwood, Chichester in West Sussex, is open until 4 November 2007; www.sculpture.org.uk/

WILFRED CASS CBE is an honorary Fellow of the Royal College of Art and a Fellow of the Institute of the Electrical Engineers. Born in Berlin, Cass has worked as an engineer, run various award-winning companies and been chairman of Moss Bros Plc. His wife finally urged him to move out of London in 1992, to West Sussex, but he hasn't stopped working

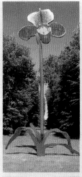

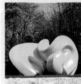

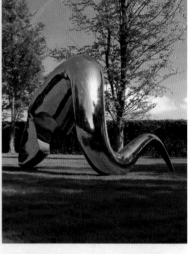

My wife Jeannette and I bought this property 17 years ago, an idyllic setting in the grounds of Goodwood, near Chichester. We placed some of the sculptures we'd collected around the 20 acres of ancient woodland in which our house is set; they looked so magnificent that we wanted to do something more interesting with the space. So we took ourselves around the world and looked at about 30 sculpture parks.

We decided to limit our ambitions and concentrate on British sculpture. There was nowhere you could go to actually see what was happening with British sculpture. And it was always going to be tough for young, emerging sculptors to break through. Since the Cass Sculpture Foundation opened in 1993, we've offered financial help to both established artists and those straight out of college. Artists can only get well known by

producing larger pieces. We quite literally use the grounds as a showcase for British sculpture. Our aim and consistent focus is to advance British sculpture and to promote it to a global audience. It's that simple.

We commission 15 to 20 large pieces of sculpture a year. We then try to get interested parties – museums, private buyers, town centres – to buy them. We use the money to commission another one.

In one way or another, we've probably spent £10m on this place – of which £6m or £7m is the initial commissioning of the sculpture. Had I not had extensive experience in business, we would have gone bankrupt a long time ago. But once we got the revolving, rolling mechanism in place, there were no funding problems. This is probably one of the few charities in the UK that is entirely funded by two people.

Clockwise, from far left: Tongue in Cheek by Tony Cragg; The Overwhelming World of Desire by Marc Quinn; I'm Alive and Declination, both by Cragg and forming part of a current, dedicated exhibition at the Cass Sculpture Foundation

"I have received more than my fair share of honours, but the greatest honour of all has been to watch the seeds that Jeannette and I planted grow and blossom into the Cass Sculpture Foundation."

The Honorary
Fellowship
of the
Royal College of Art

was conferred on
Wilfred Cass
by authority of the Chapter of Fellows at a
Convocation
held on 16th...

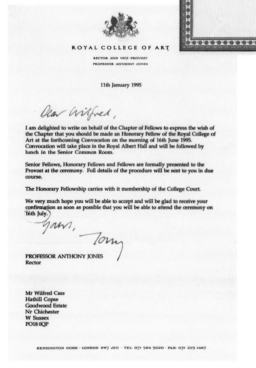

ROYAL COLLEGE OF ART

RECTOR AND VICE-PROVOST
PROFESSOR ANTHONY JONES

11th January 1995

Dear Wilfred,

I am delighted to write on behalf of the Chapter of Fellows to express the wish of the Chapter that you should be made an Honorary Fellow of the Royal College of Art at the forthcoming Convocation on the morning of 16th June 1995. Convocation will take place in the Royal Albert Hall and will be followed by lunch in the Senior Common Room.

Senior Fellows, Honorary Fellows and Fellows are formally presented to the Provost at the ceremony. Full details of the procedure will be sent to you in due course.

The Honorary Fellowship carries with it membership of the College Court.

We very much hope you will be able to accept and will be glad to receive your confirmation as soon as possible that you will be able to attend the ceremony on 16th July.

Yours,
Tony

PROFESSOR ANTHONY JONES
Rector

Mr Wilfred Cass
Hathill Copse
Goodwood Estate
Nr Chichester
W Sussex
PO18 0QP

KENSINGTON GORE · LONDON SW7 2EU · TEL: 071-584 5020 · FAX: 071 225 1467

LEARN AND LIVE

The Open University

The honorary degree of

DOCTOR OF THE UNIVERSITY

has been awarded to

Wilfred Cass

5·April·2008

Vice-Chancellor

Secretary

228

CBE presentation
ceremony, 2006
Group photo (L to R):
Mark, Jeannette,
Wilfred and Nikki Cass.

INVESTITURE

AT

BUCKINGHAM PALACE

HELD BY

THE PRINCE OF WALES

ON

Thursday
14th December 2006

at 11.00 am

OFFICERS ON DUTY

Lord in Waiting
The Viscount Brookeborough.

Master of the Household to
T.R.H. The Prince of Wales and The Duchess of Cornwall
Sir Malcolm Ross, GCVO, OBE.

erry in Waiting
der Jayne Casebury, RAF.

hancery of the Orders of Knighthoo
ander Matheson of Matheson, yr.

THE MOST EXCELLENT ORDER OF THE BRITISH EMPIRE

To be Commanders:-

Military Division:-
Brigadier Anthony Faith
Brigadier Miles Wade

Civil Division:-

Katharine Barker	For services to Social Housing.
Jean, Mrs. Couper	For services to the Administration of Justice in Scotland.
Miss Jeannie Drake	For services to the Pension Industry.
Dr. Amelia Freedman	For services to Music.
Dr. Lynne Morris	For services to Further Education in Birmingham.
Miss Barbara Wilding	Chief Constable, South Wales Police.
Mr. David Blackwood	For services to the Oil and Gas Industries.
Mr. William Capper	For services to Business and to the community in Wales.
Mr. Wilfred Cass	For services to Art.
Professor George Irving	For his contribution to the National Health Service and to the community in Ayrshire.
Mr. Andrew Kuyk	For services to the Department for Environment, Food and Rural Affairs.
Mr. John Myers	For his contribution to The Pension Service.
Dr. Hamish Wilson	For services to the Scottish Executive.

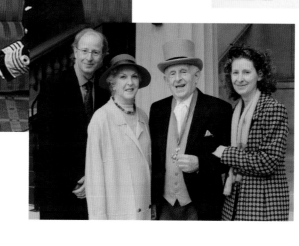

British sculpture. But it's in the background as research material, rather than taking up acres of land that we can put to better use for new work by new artists.

Making an Exhibition of Ourselves

At the beginning of the Foundation's public collection, one of the things we wanted to avoid was holding exhibitions. The collection is a dynamic exhibition in its own right – it changes regularly as new pieces are commissioned and old ones are sold. And it seemed to me that the assets and effort that went into creating and promoting exhibitions could, in our case, be put to better uses. After all, our goal has never been to get outrageous numbers through the gates or to have our names in the newspapers – we're here to sell artwork, so we can commission *new* artwork! But ten years into the Foundation's life, it became apparent that we had grown enough to be able to have changing single-artist events as well as maintaining our own model.

Jeannette and I began working with Tony Cragg in the early days of the Foundation. He has been very important to the Foundation's success, not only by sharing his talents with us through artworks he at first lent to us and, more recently, made for us on commission, but also as a member of our board of trustees, helping to steer the ship. Quite apart from all that, I think

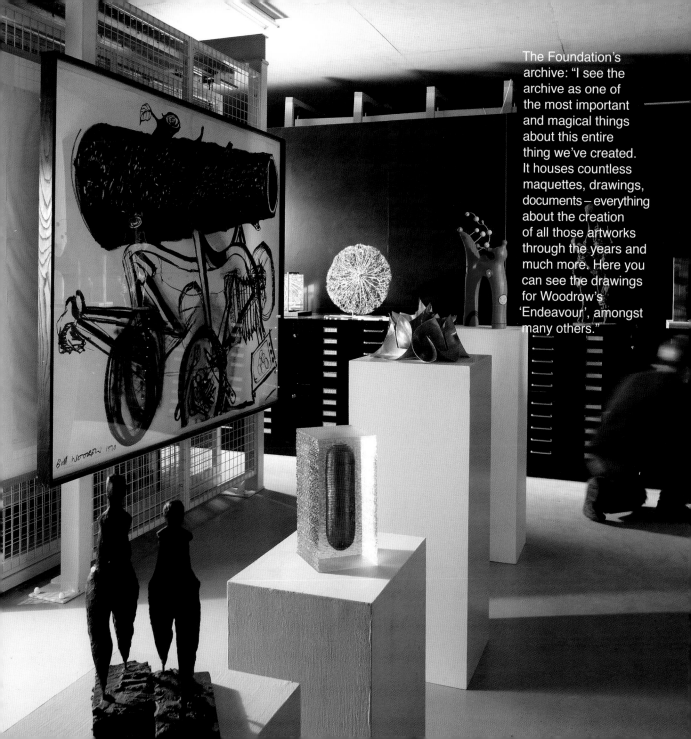

The Foundation's archive: "I see the archive as one of the most important and magical things about this entire thing we've created. It houses countless maquettes, drawings, documents – everything about the creation of all those artworks through the years and much more. Here you can see the drawings for Woodrow's 'Endeavour', amongst many others."

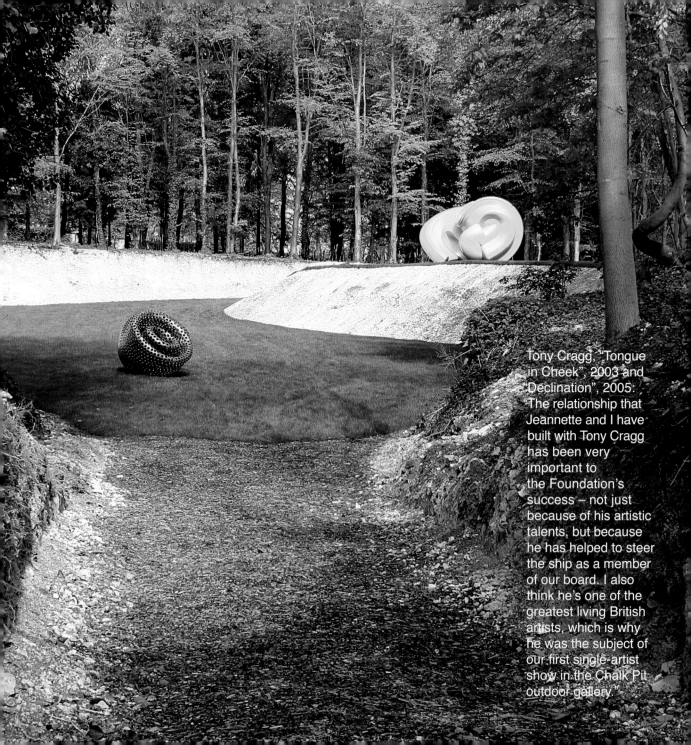

Tony Cragg, "Tongue in Cheek", 2003 and "Declination", 2005: "The relationship that Jeannette and I have built with Tony Cragg has been very important to the Foundation's success – not just because of his artistic talents, but because he has helped to steer the ship as a member of our board. I also think he's one of the greatest living British artists, which is why he was the subject of our first single-artist show in the Chalk Pit outdoor gallery."

Tony Cragg, "Mixed Feelings", 2012

he's one of the most important living British artists. For the ten-year anniversary of the Cass Sculpture Foundation we decided to forego our previous opposition to exhibitions in favour of showcasing Tony's work.

But I still felt we needed to keep the exhibition somehow separate. In 2004 I managed to persuade the Duke to let us annexe another four acres of land from Goodwood, which we christened the Chalk Pit, and turned into an outdoor gallery for single-artist exhibitions, beginning with Tony Cragg in 2005. Since then, Eilís O'Connell was the second artist to enjoy a major single-artist show in the Chalk Pit, and the American artist David Brooks became one of our first international commissions. His massive "Sketch of a Blue Whale" currently takes up most of the Chalk Pit.

Jeannette and I feel so strongly about Tony Cragg's work that we not only broke our rule against exhibitions, the Foundation also took Tony's large-scale sculptures out of Goodwood and into the heart of London. In 2012, the Foundation joined with Tony Cragg and the Natural History Museum, the Science Museum, and the V&A to stage an exhibition of five major new outdoor sculptures by Tony along the newly pedestrianised Exhibition Road in South Kensington. Along with those pieces, a number of smaller works were installed in buildings along the road.

Tony Cragg, "Versus", 2012

I believe that Exhibition Road marks an important turning point in the history of the Foundation. We had often worked with other institutions – from Fourth Plinth with the RSA, to the Guggenheim, to lending and selling sculptures to Rolls Royce, the Goodwood Estate, and others. But from its inception, Exhibition Road was different. Negotiating with the Mayor's office, commissioning and fabricating the pieces, siting them in and around Exhibition Road: everything took time and resources to make the exhibition into a perfect showcase for Tony's incredible work.

Exhibition Road's long gestation period, and the extremely high-quality result, has had a major impact on the Foundation. It showed me that the Cass Sculpture Foundation was ready to begin a new phase of its existence. We were ready to take on a wider scope, and we had the people in place not only to make that happen but, eventually, to allow me to do what I've always done once all the pieces are in place at a company I've worked with: step back.

Going International

From the beginning, the Cass Sculpture Foundation held as its mission the commissioning of new *British* sculpture. By keeping a geographic focus on an art world we already knew to some degree, we were able to get moving much quicker – and I'm not

Tony Cragg, "Ferryman", 2001, at Exhibition Road in 2012: "The Exhibition Road show we did of Tony Cragg's work during the Cultural Olympiad marks a turning point in the history of the Foundation. We created an entire exhibition along a newly pedestrianised South Kensington street – from negotiating with the mayor's office to siting the pieces, we created something beautiful and unique, and showed what the Foundation is capable of."

Tony Cragg, "Elliptical Column", 2012

one to wait around! But after 20 years, it was obvious that the Foundation's expertise and unique model was something that was ripe for expansion outside Britain.

In 2011 we commissioned our first sculpture for an international client: a Tony Cragg sculpture for a plaza in Singapore. This was certainly a turning point for the Foundation, because it was on the ensuing trip to see the piece in early 2012 that Jeannette and I first met some of the top people in China's art world. As soon as I met these people I realised that everything the Foundation had been fighting for was validated.

Often we struggle to get British and European organisations to understand the Cass model. They are reliant on outside funding and have missions that don't necessarily line up exactly with ours – organisations are more interested in creating collections. And I'm glad they do. We need collections like these! But sometimes it seems that as much as we understand and appreciate those organisations' models for collecting, they don't appreciate our model for commissioning new monumental sculpture; for creating the new works that will keep artists thinking in terms of ambitious, large-scale works.

Tony Cragg, "Points of View", 2012

When I met my counterparts from China I realised that they got the Cass model immediately. And when it came to the artists themselves and their work, we were instantly impressed with the wealth of talented and creative sculptors – impressed enough to take action. The Foundation quickly worked to secure a major international sponsor and to begin the process that will result in an exhibition, in 2015, of 20 newly commissioned pieces by Chinese sculptors. My more-than-able curator Claire Shea is already 'commuting' to China to begin the first batch of commissions, even as she seeks out other artists to work with. This show of monumental sculpture will exhibit both in China and at the Foundation in Goodwood, and plans are afoot to take the show onwards throughout Europe.

Handing Over the Reins

It has never been easy for me to leave a business that I've started, rescued, or reinvigorated. I love the chase and the battle. I love an argument, whether I win or lose, not because I love arguing but because it's in the arguing that the new ideas come forth. Sometimes you can see that those battles are destined to be lost. Though I was young, I knew that Pye was never going to go my way – too many forces opposed me that had nothing to do with good ideas or moving forward. And sometimes you simply know that things are going to move forward, like with Image Bank: even

Tony Cragg,
"Declination", 2005

David Brooks, "Sketch of a Blue Whale", 2012

at those moments when everything seemed against us, the new ideas kept me pushing onwards, and when it was time to step away, it was because other ventures called and I knew that the organisation was ready to keep going without me.

But nothing compares to the Sculpture Foundation. It wasn't a business to be started, rescued, or reinvigorated. It was – and is – an *idea*; a new way of looking at something very dear to us. And it's the idea that I created with the love of my life, Jeannette. This idea needed us to build and nurture it, but just as importantly, we needed it, to fire us forward and make retirement the busiest and most productive time of our lives. When we began the Foundation, I told people I was doing so on a 20-year plan. But since I was nearly 70 at the time, no one believed me. Now, as I write this, I'm over 88 years old, and when I tell people that I'll do this or that "in two or three years", no one doubts me anymore!

In 2012, we celebrated the Cass Sculpture Foundation's 20th anniversary in many ways, including Exhibition Road and the new projects in Asia and with international artists. Looking to the future, we hired a young and brilliant new executive director, Clare Hindle, who brought with her a level of enthusiasm and dedication matched only by her organisational skills. Thanks to

In every great age the flowering
of the arts needs its enlightened
patrons. The genius of the Foundation
can be identified in the combination
of collecting, commissioning,
commerce, exhibition, not-for-profit
and documentation which its project
uniquely draws together, slicing
transversally through the grid of all
those forces that enable artists and
creativity to thrive in society.

PHILLIP
RYLANDS
Director, Peggy Guggenheim Collection

It takes an awfully big carrot
to coax me into the countryside,
but I can't recommend a visit to the
Cass Sculpture Foundation strongly
enough.

RICHARD
DORMENT
Art Critic, Daily Telegraph

TIM
MARLOW
Director of Exhibitions, White Cube

CASS
SCULPTURE
FOUNDATION
20 years of commissioning large-scale sculpture

HATJE
CANTZ

Even the gates to the Cass Sculpture Foundation in Goodwood promise an experience out of the ordinary. Wendy Ramshaw's functional work of art is like a portal, leading to a strange world populated by the most diverse denizens–some welcoming, some more threatening as they loom through the trees. A stroll on even the dampest day through the Foundation's woodland and clearings is a gorgeous experience.

NANCY DURRANT
Arts Commissioning Editor, The Times

In a remarkable development, visual art has taken centre stage in the British cultural landscape in the last 20 years. This development, which also helped, among others, Tate Modern become a reality, was really led by the artists and sculptors. A dynamic artistic development is dependent on a complex ecology, including elements of funding, support and encouragement. I think it is far from a coincidence that the story of the Cass Sculpture Foundation runs parallel to this remarkable development.

LARS NITTVE
Executive Director, M+ Hong Kong

The Cass Sculpture Foundation has helped to maintain the creative momentum generated by sculptors in Britain over the past few decades and should be seriously congratulated for its commitment and energy.

Sculptors need imaginative patrons in order to continue and develop their work. The Cass Sculpture Foundation has created many opportunities for artists to realise new work and to share it with a wider public. Congratulations on achieving a sustainable enterprise.

NICHOLAS SEROTA
Director, Tate

Wilfred with the Cass Sculpture Foundation's Executive Director Clare Hindle, visiting four of the Foundation's commissioned pieces at Sotheby's *Beyond Limits* exhibition in the gardens of Chatsworth House

her previous experience at Kew Gardens, Clare brings a whole new dimension to the Foundation that no one coming from a traditional art gallery or museum could. She has a flair for managing both the day-to-day affairs and the overarching vision of the Foundation that makes me not only willing but excited to hand over the helm to her.

We also published a wonderful book for the 20th anniversary – *Cass Sculpture Foundation: 20 years of commissioning large-scale sculpture*. I've relied on my old friend Mervyn Kurlansky to design beautiful printed books for the Foundation since we started, but this one took on a new dimension when Ed Wilde worked with Mervyn to create a digital edition that readers can experience on their iPads.

That project led directly to this biography. In the process of sorting through the 20-year history of the Foundation, I found myself reviewing the hundreds of photos and documents relating to my own life story. And as I've organised this more personal archive, I've begun to understand a bit more about my Cassirer heritage. I discovered many traits we share; we are early adopters of ideas, technology, and culture; we act quickly and decisively; and while we are often late bloomers, many Cassirers live to ripe old ages, never loosening their grip on life.

Three of the books commissioned by Wilfred since 2010

But even the Cassirers are not immortal, and what I have learned in my business life is that, when the time has come to take a back seat to the action and allow new people to keep your work going forward, you must recognise that moment.

I have a brilliant team in place to continue the Foundation's work, including our recent appointment of John McPherson from The British Library, supported by a fine board of trustees.

So Jeannette and I are now stepping back from our direct work with the Foundation. But that doesn't mean I'll stop moving forwards – far from it. I'm as excited as ever to see what the future brings, whether that's the wonders of the latest 3D printing technologies or an innovative young sculptor; the now and the new are where I truly feel at home. Meanwhile, we'll continue to look out that window we love so dearly – the one at which the Foundation's original idea struck us – to see our legacy grow and evolve.

And, knowing me, everyone would be surprised if I didn't have a new idea to contribute from time to time, wouldn't they?

Wilfred and Jeannette, 2013, in front of the Hathill Copse window where they were first inspired to create the Cass Sculpture Foundation

Author
Wilfred Cass

Design
Mervyn Kurlansky

Editing
Lucy Greeves
Justin Hopper

Production
Ed Wilde

Cassirer Research
Ann Elliot

Scanning
Barney Hindle
Naty Lopez-Holguin

Photography
Roger Bamber
Peter Cook
Leon Chew
Mike Caldwell
Mark Cass
Wilfred Cass
Charles Duprat
Bob Elsdale
Barney Hindle
Rex Jobe
Mervyn Kurlansky
Ed Wilde

It is the author's wish that all proceeds from this book and its digital forms are to be gifted to the Cass Sculpture Foundation, a British charity set up to commission new and pioneering works from emerging and established international artists.
www.sculpture.org.uk

The history of the Cassirer family is well documented in 'Die Cassirers', Georg Bruehl. Edition Leipzig, 1991
ISBN 978-3-3610030-2-6

Printed in China by Imago

Available on the iBookstore